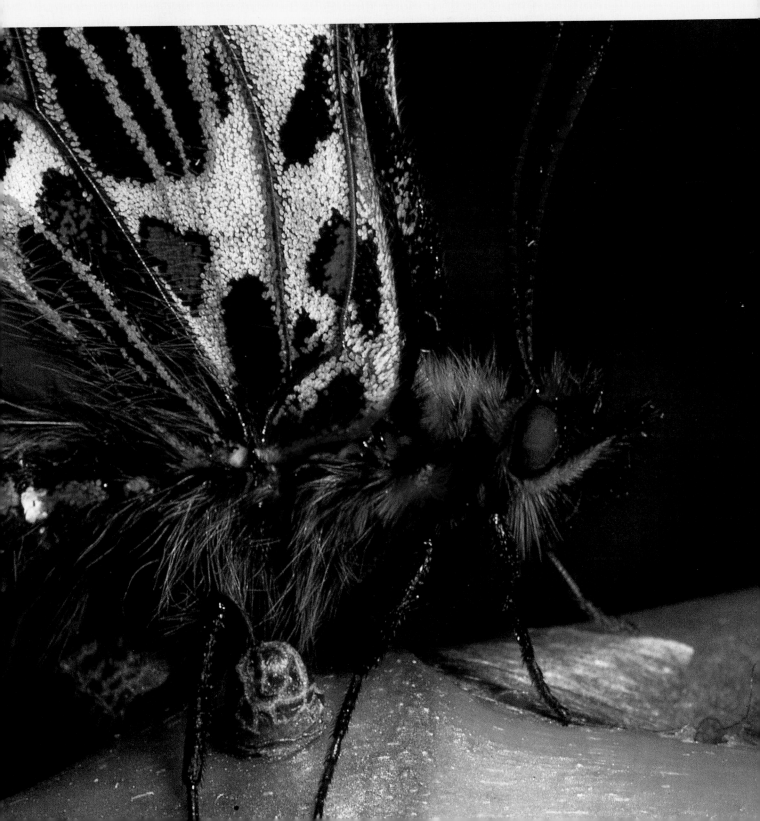

THE COMPLETE GUIDE TO
CLOSE-UP & MACRO
PHOTOGRAPHY

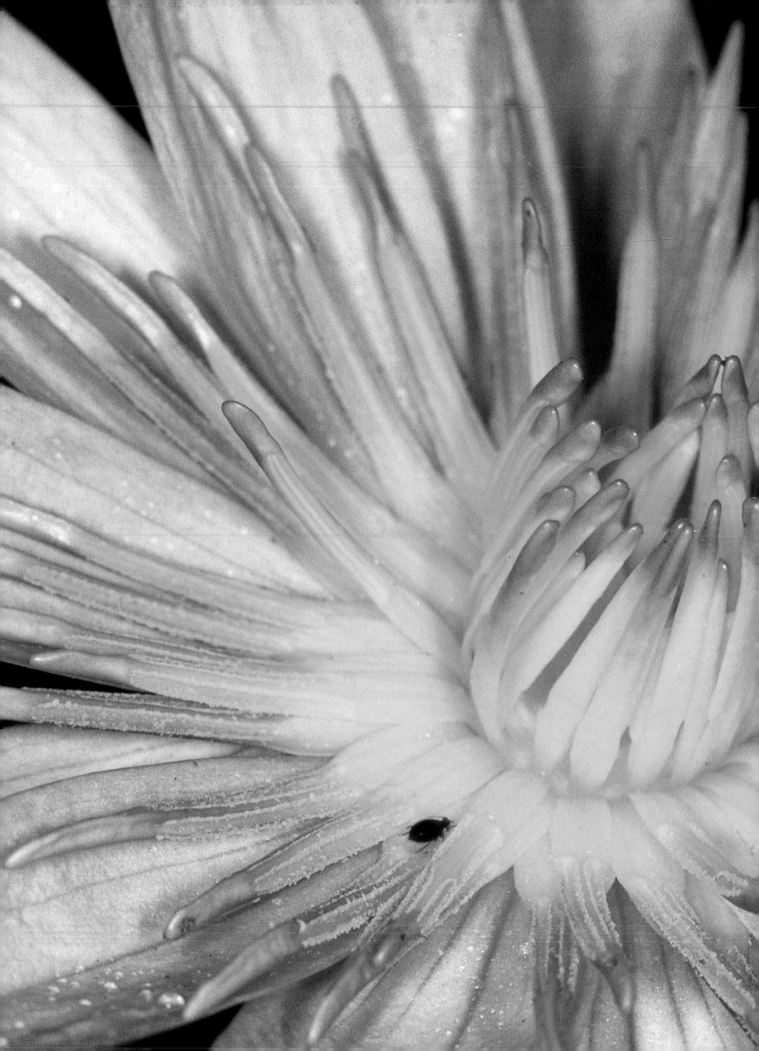

THE COMPLETE GUIDE TO
CLOSE-UP & MACRO
PHOTOGRAPHY

PAUL HARCOURT DAVIES

David & Charles

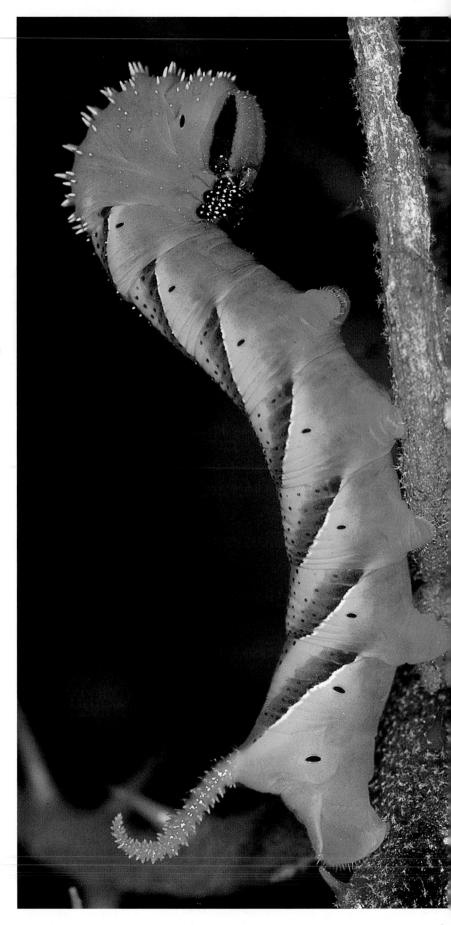

A DAVID & CHARLES BOOK

First published in the UK in 1998
Reprinted 2000

Designed by Ian Muggeridge

Printed in Singapore by C.S. Graphics Pte Ltd.
for David & Charles
Brunel House
Newton Abbot
Devon

page 1
EASTERN FESTOON BUTTERFLY, *Allancastria cerysii*. Canon 50mm f/3.5 at f/16 used in reverse on a 50mm extension tube to give x 2.4 magnification on film.
page 2-3
WATER LILY. Tamron 90mm f/2.8 SP AF macro at f/16 with SB21B macroflash. Fujichrome Provia.
right
DEATH'S HEAD HAWKMOTH LARVA, *Acherontia atropos*. Olympus 80mm f/4 bellows macro lens at f/22 with twin SB23 flashguns. Fujichrome Velvia.

Contents

Introduction

Several decades ago, photography at close quarters was the province either of the specialist with a laboratory training or of enthusiastic amateurs who fixed wire frames and other gadgets to the fronts of their cameras in an attempt to achieve sharp focus. The coming of the Single Lens Reflex camera enabled the user to see through the lens and view exactly what the camera could.

A certain amount of confusion has grown up over the use of the term 'macro', largely because lens manufacturers use it in arbitrary fashion to sell lenses. Any lens which can focus slightly closer than you'd expect carries the label 'macro facility' or 'macro focusing' somewhere. Close-up photography is concerned with anything from about 1/20 magnification (reproduction ratio 1:20) up to life-size (1:1) on film. Macro photography strictly embraces magnifications from life-size (1:1) up to about 25 × magnification. However, a first wave of so-called 'macro lenses' offered a reproduction ratio of 1:2 without extension tubes, so the term has come to be employed with magnifications from 0.5 × upwards. Photomacrography, which is not the province of this book, uses specialist equipment and deals with magnifications from around 25 × to 100 ×: beyond that lies the province of the microscope.

Many 'macro' lenses with autofocus allow you to get down to life-size: higher magnifications require more specialised equipment, but wherever possible this book shows you how to get magnified images of high quality by using teleconverters or reversing and coupling lenses you might already have to hand.

By far the most popular area for close-up and macro photography lies in the natural world, where even the most modest of back gardens offers scope for a safari. For as long as I can remember I have had a passionate interest in anything to do with natural history and much of my photography and writing is directed towards that area. But I find numerous opportunities to apply close-up techniques to many other subjects around me, from postage stamps, coins, small antiques and models to the wealth of pattern and texture in tapestry stitches, cracked mud, stone surfaces – the list is limited only by the imagination.

Modern cameras make it possible for anyone to achieve excellent results but people are often disappointed and feel there must be some magic to it – there isn't. It does take a bit of care and determination, as this book shows, but above all it is fun.

The book takes the reader through the vast array of equipment available – from cameras and lenses to accessories – and then considers the various ways of getting different degrees of magnification. It gives guidance in the continual battle to obtain correct exposure and adequate depth of field, and suggests approaches to composition which will give your pictures impact. These ideas are applied to a whole range of different opportunities for close-up work, both outdoors and indoors.

Finally, there is a look at storing and manipulating images before taking the plunge when, perhaps flushed with your success in trying out the techniques explained here, you consider trying to get your work published.

Why does seeing things at close quarters have such an appeal? Perhaps it is because we are introduced to a world just beyond the familiar, where insects become monsters and the commonplace takes on striking beauty. Children love detail and looking at things in close-up brings back this childlike sense of wonder. As a photographer working with close-up and macro photography you can have the double delight of exploring hidden worlds yourself and, through your pictures, opening the eyes of others to their secrets.

Paul Harcourt Davies
September 1998

facing page
CYPRUS FESTOON CATERPILLAR, *Allancastria cerysii* **var** *cypria* **on Dutchman's pipe food plant.** Nikon 105mm f/2.8 at f/16 with SB21B macroflash. Kodachrome 64.

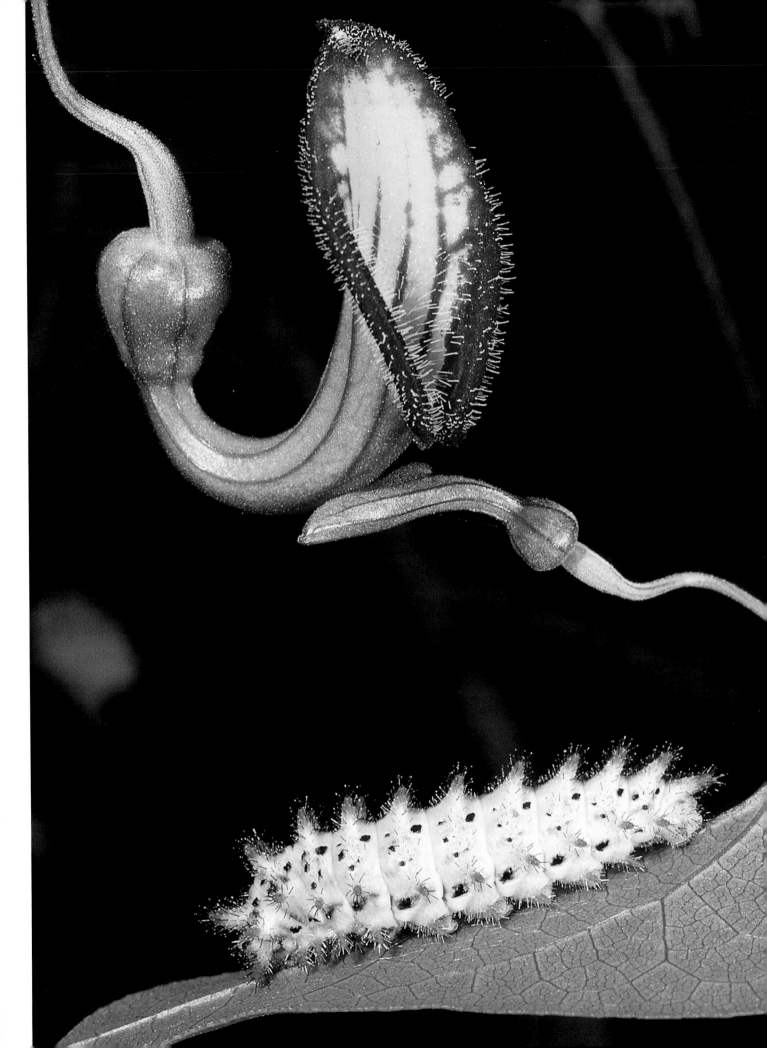

1 HARDWARE & BASICS

BUYING into a camera system is an expensive investment. You will always be able to convince yourself that a new gadget or lens is indispensable. Exhibitions such as those mounted by BBC Wildlife/British Gas attract the world's best photographers. The captions show that the equipment used is dominated by the names of one or two manufacturers. The photographers have bought reliability, proven excellence and quality with their system of choice, but their skills would still be evident with any equipment. Do not be put off if your budget will not stretch to the top brands – get the best you can afford. Most cameras and lenses are capable of far more than their users demand.

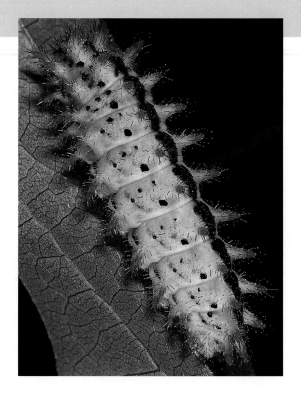

Reflex Cameras

Owners of 35mm camera systems are, on the whole, better served for close-up photography than owners of medium and larger format cameras. The lower cost of equipment and film materials, the convenience of handling and the availability of autofocus and sophisticated exposure metering systems makes 35mm the sensible choice for most close-up and macro work.

Choice of a system is a difficult matter when most major manufacturers offer a wide range of lenses and other accessories and independent manufacturers help widen the options further. You will be largely influenced by personal recommendation and simply what feels right to you when you handle a camera. Always ask fellow enthusiasts and don't forget your local camera shop, where the back-up when you need help and advice after purchase is well worth the slightly higher prices sometimes charged.

Ironically, enthusiasts were even better served before the autofocus revolution occurred. The now-defunct Exacta system offered a bewildering array of items designed for 'scientific' photography: both Minolta and Topcon listed series of short focal length macro lenses, each computed and corrected for a particular magnification range.

In recent years, the Olympus Optical company has served the interests of the macro enthusiast better than any other manufacturer. They offer a range of macro lenses, a selection of specialised stands and flash heads and were the first to employ TTL flash metering.

The introduction of single lens reflex (SLR) viewing systems has made close-up photography far easier for the ordinary enthusiast because the mirror and pentaprism combination enables you to see the subject as it will appear on film. Older books show rangefinder cameras fitted with wire frames to gauge subject distance, which made close-focusing a hit-and-miss affair. Leica were the first camera manufacturer to tackle the question of viewing through the lens with a periscopic attachment, the 'Visoflex', which fitted between camera body and lens.

above

CYPRUS FESTOON LARVA, *Allancastria cerisyi* **var.** *cypria.* Nikon 105mm f/2.8 AF macro at f/22 with SB21B macroflash. Kodachrome 64.

At close quarters the SLR scores over all other camera types: the slightest movement can send the subject in and out of focus and this can be seen directly in the viewfinder. Exposure can be made using natural light or flash according to prevailing conditions or taste.

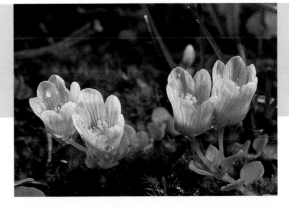

above left

Bog pimpernel, *Anagallis tenella*. Nikon 60mm f/2.8 AF macro at f/16 with SB21B macroflash. Kodachrome 64. **With an SLR camera any photographer can get down to a subject and fill the viewfinder with the smallest of flowers or insects. 35mm systems allow by far the greatest flexibility of use and range of accessories for exploring the world of close-up and macro photography.**

Cornfield weeds, Italy. Nikon 24mm f/2.8 AF at f/16. Fujichrome Velvia. **The SLR camera permits you to see exactly what the camera sees, making framing and focusing much easier. The photographer can choose the elements in the field which are to be sharp and then mix frontal and back-lighting, as in the picture.**

Selecting a System

If a lot of your work will involve photography at close quarters, there are several factors which might sway your choice of camera type.

Compact systems with a close-focus facility and autofocus work well – but when the 'bug' bites many people find them limiting. The much vaunted APS (Advanced Photo System) was designed to facilitate automatic processing, with the concession to the user being the choice of three different picture formats from the same film. If quality had been the first concern, better use could have been made of 35mm film by eliminating sprocket holes to give a negative or transparency of 40 × 30mm. Major manufacturers have introduced APS bodies compatible with their existing lens systems. However, the APS format currently offers no advantages over 35mm for close-up and macro work.

AUTOFOCUS (AF)

Nowadays, it is difficult to find a reflex camera which does not offer autofocusing. Although the facility is useful and convenient when using zoom and telephoto lenses it can become a nuisance in the close-focus range where the lens 'hunts', moving back and forth in response to the slightest movement of subject or camera.

Newer models from Canon, Nikon and others enable you to focus on points off-centre. Predictive mechanisms allow for subject movement and respond extremely quickly when compared to cameras just a few years old. Contax have a revolutionary approach to autofocusing which involves movement of the film plane and not the lens. It cuts out the need for motors in every lens and is extremely fast and accurate in use.

In the close-up range I usually switch off the autofocus (after using it to change magnification). The switch is again in the off position when taking landscape shots, where I often want to make use of the hyperfocal distance to maximise depth of field, while the point of focus I want is unlikely to be at the centre of the picture.

below left
WATER LILY HYBRID and *facing page top* **DAHLIA HYBRID.** Tamron 90mm f/2.8 SP AF macro at f/16 with SB21B macroflash. Fujichrome Provia. **A drawback with older AF designs is that the autofocus sensor operates at the centre of the image field. If you want to compose with an off-centre subject you have to focus, set an autofocus lock and then move the camera slightly. It is not easy to do this, particularly with a moving subject, and still maintain sharp focus.**

facing page
ROBIN MOTH, *Hyalophora cecropia.* Nikon 105mm f/2.8 AF macro at f/22 with twin SB23 flashguns. Fujichrome Velvia. **Modern TTL systems are convenient, accurate and will give you a high proportion of correct exposures per film – an important consideration where cost is concerned. Many cameras now boast TTL flash metering, which can be extremely useful in close-up and macro work, as long as you have mastered its idiosyncrasies.**

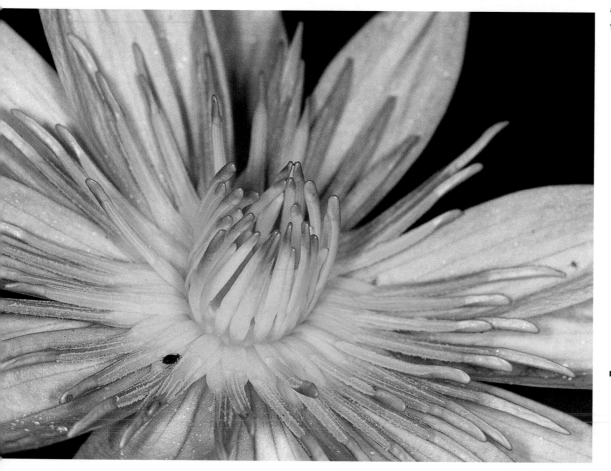

THROUGH THE LENS (TTL) METERING

Many users of medium and larger formats swear there is nothing to beat a hand-held meter or a separate spot meter. I confess I use TTL metering in both 35mm and medium formats but I modify the camera reading whenever experience tells me the lighting conditions are 'tricky'.

DEPTH OF FIELD PREVIEW

On modern cameras you focus with the lens diaphragm wide open, which gives the brightest possible image in the viewfinder; the lens stops down to the taking aperture when the shutter release is pressed. In the close-up and macro ranges depth of field is shallow at the widest aperture, so it is useful to be able to stop the lens down to see what the final depth of field might be, then

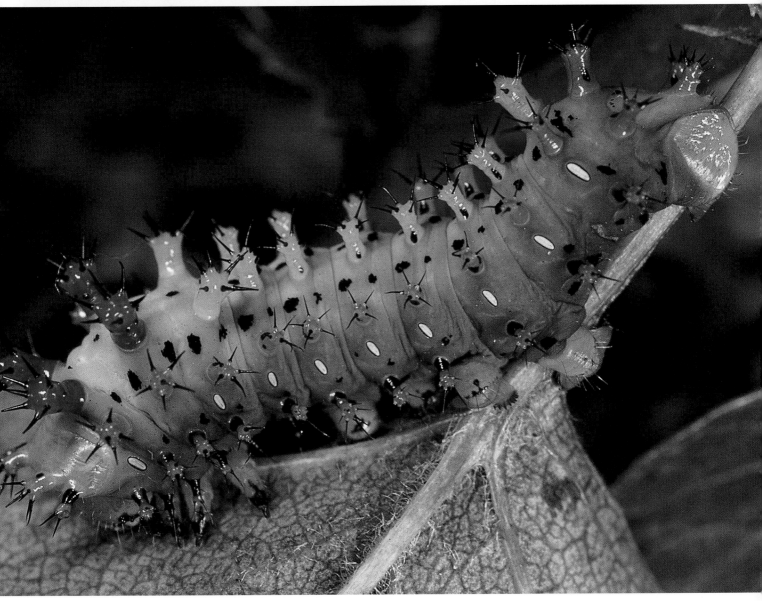

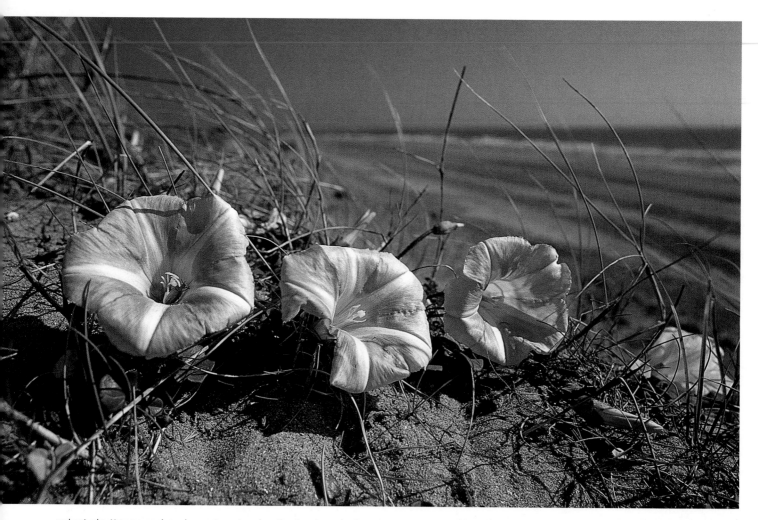

select shutter speed and aperture to give the best compromise. Annoyingly, many camera manufacturers have decided that a 'depth of view preview' lever is something they will now only incorporate in models at the top of their ranges.

MACRO LENSES

Many 35mm systems boast two or more 'macro lenses' – one of 'standard' focal length (50-60mm) and another 'portrait' lens of 90-105mm. Medium format systems usually have one 'macro' objective, typically with a focal length of 120mm (6 × 6cm) or 140mm (6 × 7cm) and these need an extension tube to give 1:1 reproduction. Mamiya's 645 system has two macro lenses of 80mm and 120mm focal length, and the latter gives life-size magnification without an extension tube.

INTERCHANGEABLE VIEWFINDER SCREENS

The general purpose viewing screen supplied with many cameras has a central 'split image' prism which inconveniently blacks out either when used at close quarters or with telephoto lenses. This central part is then surrounded by a 'microprism' collar and the rest of the screen is ground glass. For the close-up or telephoto work which constitutes much natural history photography the best bet is a plain ground glass screen – with or without a grid (useful for landscapes) – on which a central circle denotes the metering area.

The flagship 'pro' cameras in most ranges offer interchangeable screens. With work involving higher magnifications the viewfinder can become very dark when you stop down to preview depth of field – the clearest, brightest screen for this purpose is plain ground glass with a central clear spot on which cross hairs are etched. Pin-sharp focus is obtained by the 'no-parallax' method: focus is exact when object and cross hairs do not separate as you move your head slightly from side to side.

If your system does not offer interchangeable screens, you might consider a Beattie screen. These are available for a vast range of cameras and can be fitted by any good camera repairer.

SEA BINDWEED, *Calystegia soldanella.* Nikon 24mm f/2.8 AF at f/16. Fujichrome Velvia. **The convenience of a 'macro' lens is its extended focusing thread, which allows close-focusing without using extension tubes. But don't worry if the 35mm system of your choice offers only one macro lens – independent manufacturers, notably Tamron, produce some of the best macro lenses around.**

FERN SPORES AND PSORII. Olympus 38mm f/3.5 macro bellows lens at f/11 with single SB23 flash. Fujichrome Velvia. **If a camera has its metering system in the pentaprism the mirror will block this off when it is lifted, so you have to meter before using the exposure lock facility. With cameras such as the Olympus OM4 Ti and Nikon F4 there is a metering cell in the body, making exposures possible while the mirror is up. These cameras are ideal if you want to use all manner of lenses for ultra-close-up work and still retain TTL flash metering.**

MIRROR LOCK-UP

Once upon a time most reflex cameras had a small lever to lock up the mirror before pressing the shutter release. Just before an exposure, the mirror moves upwards at an appreciable speed. Although the mirror's energy is absorbed by a damping mechanism there is a residual camera shake which can result from shutter bounce and can affect sharpness at slow shutter speeds. With medium format cameras possessing a focal plane shutter, a mirror lock-up is essential for critical sharpness at speeds longer than about $1/15$ sec with natural light.

Some cameras have a lock-up facility which works with the timed exposure button – this can be perfectly adequate as long as the subject stays still during the count-down process.

BELLOWS AND EXTENSION TUBES

If your system of choice offers a range of extension tubes and bellows, fine – but the independent ranges are just as good and often cheaper.

SOUTH WALES HERITAGE COAST. Mamiya 645 Super 45mm f/2.8 at f/16. Fujichrome Provia. **Where a choice of viewing screens is possible with a SLR camera, a good general purpose screen is plain ground glass with a grid of lines superimposed. The grid aids framing, particularly with roll film cameras, and, in the case of landscapes, helps to make sure the horizon is horizontal.**

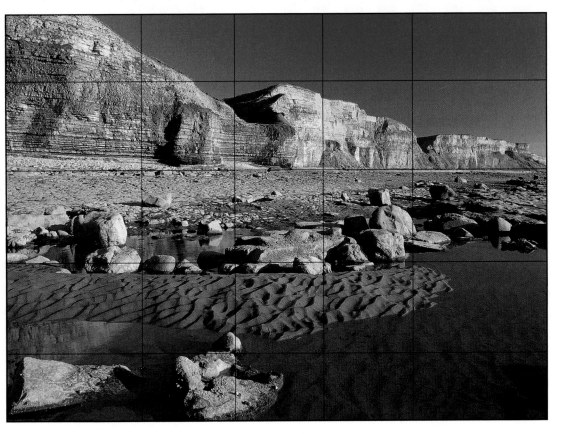

Medium Format Systems

The major manufacturers of medium format systems make provision for close-up and macro photography with one or even two dedicated macro lenses, bellows and extension tubes – at a hefty price. Some medium format cameras (Mamiya RB67 Pro S and RZ67, Fuji GS 680) already have a useful in-built bellows extension.

One discontinued medium format camera, the Rollei SL66, was clearly designed with close-up work in mind. Its superb Zeiss lenses could be simply reversed onto the front lens mount. Its in-built bellows offered a rising front and a swinging lens panel and allowed 1:1 and greater magnifications. Even second-hand, these cameras are far from cheap, but they were so well made that they continue to give excellent service.

If you are thinking of purchasing a roll film camera remember:

• For larger prints, such as posters, roll film formats certainly score since the final image needs to be enlarged fewer times from the original transparency and detail is retained without the grain structure breaking down.

• Cost of film and the more mechanical approach needed for medium format photography makes you take care – when you are tired after an exhausting day's fieldwork it is easy to be tempted to cut corners with 35mm. The discipline imposed by the larger format rubs off on your 35mm technique especially with exposure.

• Reversed macro lenses for 35mm and enlarger lenses, when used, possess a large enough image circle to cover roll film formats. I can use my Olympus macro lens heads on a Mamiya 645 with a modified body cap as an adaptor, and the Mamiya 80mm is used with an adaptor on a Nikon bellows, where the larger image circle allows a degree of camera movement such as shifts and tilts.

• In 35mm format landscapes you can lose fine detail and subtle tonal gradation in subjects such as bright yellow flowers. With a larger format the flower image occupies a greater area on film, using more grains of emulsion so that subtle detail is not burned out nearly so easily.

RED ONION, 35mm format (above). Nikon 60mm f/2.8 AF macro at f/16. Fujichrome Velvia.

RED ONION, medium format (right). Mamiya 80mm f/2.8 macro at f/16. Fujichrome Provia. **There is a tradition of 'bigger must be best' and some picture editors are not used to viewing the smaller formats. There is no doubt that larger transparencies do look better on a light box: if you wish to make sales in these markets then you have to give clients what they want.**

THE CASE FOR MEDIUM FORMAT

Photographic magazines have long perpetuated a 'debate' regarding the best camera format to use. Since the advent of desk-top scanners many magazines have begun to work in an A4 format and their publishers prefer to use 35mm format transparencies.

For some calendar and advertising work clients specify roll film transparencies but then make no distinction between 6 × 4.5cm, 6 × 6cm, 6 × 7cm or even 6 × 9cm formats.

For markets where 35mm will simply not be considered, many professionals have their 35mm shots 'duped' to a larger format. The depth of field will be that of the original transparency – an advantage which outweighs any barely perceptible increase in granularity arising from enlarging the 35mm picture.

The largest that most published transparencies are blown up is a double-page A4 spread (if the photographer is very lucky). By the time any picture has been scanned – even if 'enhanced' with Adobe Photoshop – and then subjected to the printing process it will have lost definition. In magazines, results from transparencies on the Kodachromes or Fuji's Velvia and Provia films are usually indistinguishable from those taken on larger formats.

So, is there any point in using medium or larger format equipment for close-up and macro work? The answer is a considered yes, but in the close-up rather than the macro realm. I use a Mamiya 645 Super with increasing frequency, although it was purchased for 'bread and butter' stock landscape and travel shots. The 45mm wide-angle and 80mm macro lenses are most often pressed into service. Optical quality is superb and the 45mm with smallest extension tube allows a magnification of × 0.25, perfect for shots of plants in the landscape when stopped down to f/22.

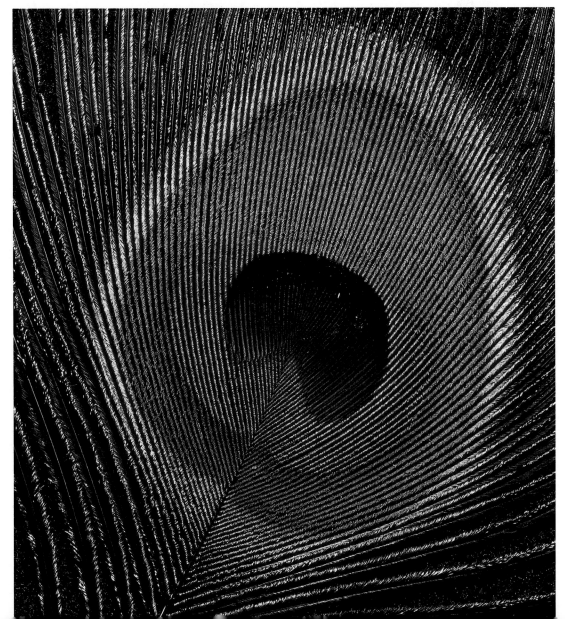

PEACOCK FEATHER. Mamiya 645 with 80mm f/2.8 macro at f/16. Fujichrome Provia. **To get full advantage from using a larger format, the image must occupy the same proportion of the film as it would in 35mm, which means a bigger magnification on film. Depth of field is entirely dependent upon magnification and not the focal length of lens used so a frame-filling close-up shot in a larger format will have a shallower depth of field than the same shot in 35mm.**

Aperture & F-stops

The speed of the camera shutter and the aperture of the lens are used to control the amount of light which reaches a film in order to expose it correctly. The lens aperture is essentially a hole through which light passes. Its size can be varied by rotating a ring on the lens which is connected to the series of interlocking blades which form the iris diaphragm.

Lenses are marked in a series of numbers or 'f-stops' which denote the size of the aperture and run in a series:

f/1, f/1.4, f/2, f/2.8, f/4, f/5.6, f/8, f/11, f/16, f/22, f/32

decreasing size ⟶

The larger the number the smaller the diameter of the aperture in the diaphragm.

Moving from one f-number to the next produces a change in area of the aperture by a factor of *two*: the amount of light reaching the film is doubled if the aperture is opened up by 1 stop and halved if it is closed down by the same amount (see Appendix).

Modern film emulsions, especially those for colour transparencies, are sensitive to small changes in exposure: for critical work changes of 1/2 or even 1/3 of a stop produce noticeable differences of colour saturation in the final transparencies. 'Click' stops denote full f-stops on most lenses, though some have them for 1/2 stops as well. Usually, intermediate settings (1/2 or 1/3 stop) are set by guesswork, either using a reading from a hand-held meter or watching a display in a viewfinder. Exposure can also be fine-tuned using the exposure correction dial which is now a feature of most SLRs. The dial is calibrated in 1/3 stops – mainly useful for fine-tuning the ISO rating of a film or for bracketing exposures. With automatic settings in 'aperture priority mode' (the most useful one for close-up) you set the aperture and the camera adjusts the shutter speed. Electronic shutters can use intermediate shutter speeds to give better than 1/3 stop accuracy.

DEPTH OF FIELD, DEPTH OF FOCUS AND CIRCLES OF CONFUSION

In close-up and macro photography, f-numbers and the size of the lens aperture take on a vital role because they are related to the depth of field – the distance either side of the point of sharpest focus in a photograph where the image still appears sharp. The smaller the aperture (and the larger the f-number) the greater the depth of field.

In an idealised lens system, each point on an object corresponds to a point on an image – light from a point on the object is brought to a focus by

DEPTH OF FIELD

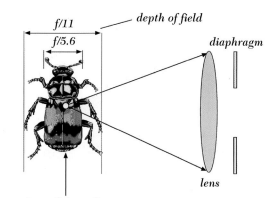

Points either side of the plane of sharp focus will still appear 'sharp' on the film as long as they are imaged smaller than the 'blur circle'. The distance either side of the plane over which this happens is the depth of field. It increases as the aperture becomes smaller.

DEPTH OF FOCUS

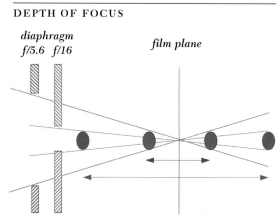

As the diaphragm is closed down, only rays close to the centre of the lens pass through. The discs represent the 'blur circle' which will appear as a sharp point on film. The arrows show the latitude in the position of the film plane for a sharp image, or depth of focus. The smaller the aperture the greater is the freedom of movement either side of the lens.

facing page
MONKEY ORCHID, *Orchis simia.* Nikon 60mm f/2.8 AF macro at f/22. Fujichrome Velvia. **In close-up photography there is a continual battle against the limits of depth of field. Success depends not only on good technique but also on seeing which elements of the pictures you want to have in sharp focus and adjusting your position to get the best result.**

CARLINE THISTLE, Carlina vulgaris. *top right* f/5.6 and *bottom right* f/22. Fujichrome Velvia. **The paired photographs show the effect on the depth of field of decreasing the aperture. At reproduction ratios of 1:1 and more the photographer has at most a few millimetres to play with and careful focusing is critical.**

a lens as a sharp point and the image is built up from these points of light.

The human eye has its limits, and sees very small circles as sharp 'points'. Someone of 'normal' vision can resolve objects separated by one minute of arc ($1/60$ of a degree). For 35mm photography this is related to a 25 × 20cm (10 × 8in) print viewed from a distance of 25cm (10in): at this distance a circle of 0.03mm ($1/850$in) diameter is indistinguishable from a 'point'. This is the so-called circle of least confusion or 'blur circle' used to calculate depth of field tables and hyperfocal distances (see Appendix).

Photographic magazines sometimes use the terms 'depth of field' and 'depth of focus' as if they were interchangeable: the diagrams (see page 18) show they are not. Depth of focus becomes important when dealing with camera movements in larger format cameras.

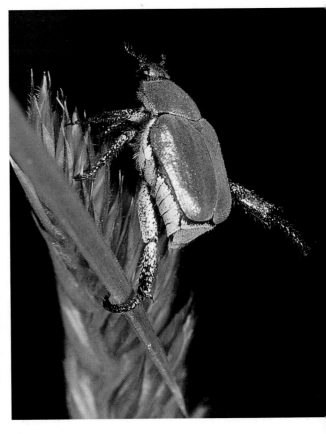

above

HOPLIA, Hoplia caerulea. Nikon 105mm f/2.8 AF macro at f/22. Kodachrome 64. **It often makes sense to photograph a small subject such as a beetle at 1:1 on film and then enlarge the result as needed. The final print then has the same depth of field as it would at 1:1; taking the shot at x 2 magnification would halve the depth of field.**

Depth of Field Limits & Diffraction

To get greater depth of field it would seem that all you have to do is use apertures of smaller and smaller diameters. Certainly, early landscape photographers produced stunning black and white results with wet-plate cameras and lenses of aperture f/64. Unfortunately there is another problem – diffraction – which arises with small apertures and destroys image sharpness.

When light passes through any aperture the light waves are affected by the edges of the aperture; the smaller the size of the aperture the more pronounced the effect becomes. The result is a spreading of the light which begins to soften the image. In reality, each image 'point' is a tiny diffraction pattern – a series of concentric rings with the largest and brightest ring at the centre. The outer, less bright, rings do not become noticeable unless the aperture is very small. When they do, the image begins to look 'fuzzy'. It is this same phenomenon of diffraction which limits the resolution possible with optical telescopes and microscopes.

In photography at higher magnifications the problem is to choose an aperture which balances adequate depth of field against the onset of diffraction which creates image deterioration.

SHARPNESS

As you get more deeply involved with close-up photography you tend to demand more of a lens – every hair on a bee's knees has to be bitingly sharp.

The perception of sharpness depends on two things: how a lens separates fine details (its resolving power) and the way it copes with changes from light to dark or from one shade of colour to another, particularly at object boundaries (contrast). Film choice also has a great deal to do with this (see page 58).

Resolving power is quantified by relating it either to 'blur circles' (circles of least confusion) or to closely drawn pairs of lines (line pairs per mm). For the standard 25 × 20cm (10 × 8in) print viewed at 25cm (10in), a circle of confusion of 0.03mm (1/850in) diameter is equivalent to a resolution of 8

FUCHSIA STAMENS. Olympus 20mm f/2 macro bellows lens set at f/11 at × 10 on film. Fujichrome Velvia. **The smaller the size of the aperture the more pronounced the diffraction. This results in a spreading of the light which begins to soften the image. The art is to select the aperture which gives you as great a depth of field as possible before the effects of diffraction become noticeable.**

line pairs per millimetre (lp/mm). More information on resolving power is given in the Appendix.

Most camera lenses can out-perform the abilities of most photographers using them. Yet, even if you manage to get everything 'right' – you use a highly corrected macro lens, employ very fine-grain film, have mastered lighting to create good relief and managed to eliminate vibrations of the camera (with a mirror-lock and support) and of the subject — someone else's pictures may still be sharper than yours.

From personal experience, backed up by numerous conversations with photographer friends and colleagues, here's a list of the lenses which I think have this 'certain something'. It is highly subjective and not exhaustive.
- Nikon: Micro Nikkor 55mm f/2.8; Nikkor 60mm f/2.8 AF Macro.
- Leica: 60mm f/2.8 Macro-Elmarit R; 100mm f/4 Macro Elmar R (including bellows version); 100mm f/28 Apo Macro-Elmarit.

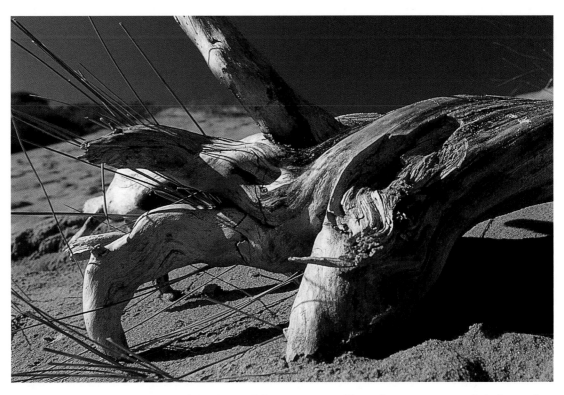

SUN-BLEACHED DRIFTWOOD. Nikon 24mm f/2.8 AF wide angle at f16 with circular polarising filter. Fujichrome Velvia. **The perspective distortion produced by a wide-angle lens can be used to accentuate shapes, here providing the almost 'animal' appearance of drift wood on a sand dune.**

frame; a degree of movement of the front of the lens brings the top of the image into the frame while the camera is horizontal, allowing you to correct converging verticals. The usefulness of shift lenses in nature photography is limited, especially since they do not focus particularly closely (though they are useful for studies of trees).

Limited use has been made in 35mm photography of the camera movements which are essential to users of large format cameras. Only Canon has ever taken this seriously, first with an excellent tilt and shift lens for their FD mount, the 35mm f/2.8 TS, and now with three separate optics: TS-E 24mm f/3.5; TS-E 45mm f/2.8 and TS-E 90mm f/2.8 for their EOS system. These lenses have good close-focus capabilities plus the ability to increase depth of field at wider apertures by tilting the lens.

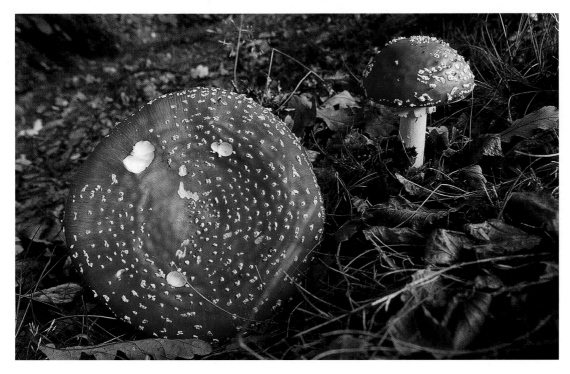

FLY AGARIC, *Amanita muscaria.* Nikon 28mm f/2.8 manual wide angle at f16 with fill-in flash. Fujichrome Velvia. **Many wide-angle lenses, particularly older manual designs have a useful close-focus facility allowing them to be used up to 1:4 scale of reproduction. The perspective creates far more interesting 'record' pictures than a standard lens of around 50mm focal length.**

Macro Lenses

In practice, if you use a tripod, focus correctly and are a competent photographer you will not see much difference in results from a macro design and an 'ordinary' lens of the same high quality up to around half-life-size to life-size magnification.

MACRO LENSES FOCAL LENGTH 50-60MM

Macro lenses offer quality (reflected in their price), convenience and an ability to focus close and give, in the case of modern designs, 1:1 magnification while maintaining aperture and meter connections with your camera. They are also specially corrected for work close to the subject. The angles which light rays make with the front lens surface have an important effect on lens aberrations: in 'macro' lenses the corrections are optimised for an image ratio of about 1:10. Modern designs have a further refinement: they incorporate a 'floating element' which can move as image reproduction changes to maintain the corrections.

MACRO LENSES FOCAL LENGTH 80-105MM

One of the questions most often asked is 'Which focal length macro should I buy?' Bearing in mind cost and convenience, the most useful single focal length in 35mm format is in the 'portrait range' from 90mm to 105mm and its equivalent in medium format (see page 14).

These lenses provide a slightly flatter perspective than lenses of around 50mm focal length and an increased working distance, useful with shy subjects whether used with natural light or a 'macroflash' set-up.

Most camera manufacturers provide macro lenses of exceptional quality in this range, offering autofocus down to a reproduction ratio of 1:1. The first 1:1 designs had an extended internal thread which provided extension much as an extension tube does, but current designs for autofocus lenses use internal focusing, in which one or more elements are moved relative to the others. This

facing page
DUNE PANSY, *Viola tricolor* ssp. *curtisii.* Nikon 60mm f/2.8 AF macro f/16. Fujichrome Velvia. **I use a 60mm f/2.8 AF Nikkor for natural light close-ups of flowers where it offers a perspective I like. In high mountain regions I like to travel light on exploratory walks before lugging camera bags and tripods – the usual outfit is a single camera body, a 60mm f/2.8 macro, a 28mm f/2.8 wide-angle which has a good close-focus capability and a small flash.**

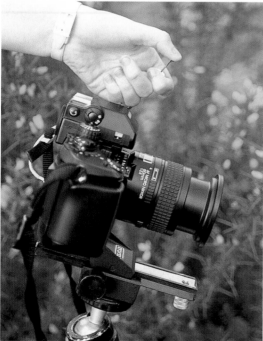

CAMERA WITH MACRO LENS. With natural light it makes sense to use a tripod and focusing slide to achieve precise focus. At close quarters it is better to move the camera rather than use the lens to focus: with a medium format camera I find the focusing slide indispensable.

CLOSEST FOCUS DISTANCE AT 1:1
A COMPARISON OF MACRO LENSES

The 105mm lens offers a greater working distance. However, with a macroflash such as Nikon's SB21B the 'relief' is slightly better with the shorter focal length lens. Light comes from about 35° off axis with the 60mm lens compared with 20° for the 105mm lens.

Nikkor 105mm f/2.8 AF Macro

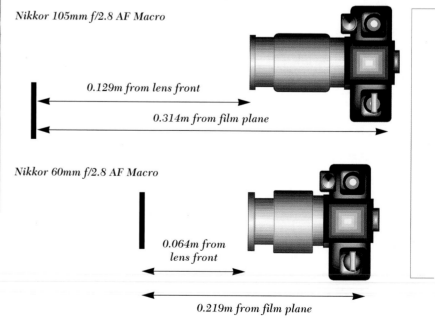

0.129m from lens front

0.314m from film plane

Nikkor 60mm f/2.8 AF Macro

0.064m from lens front

0.219m from film plane

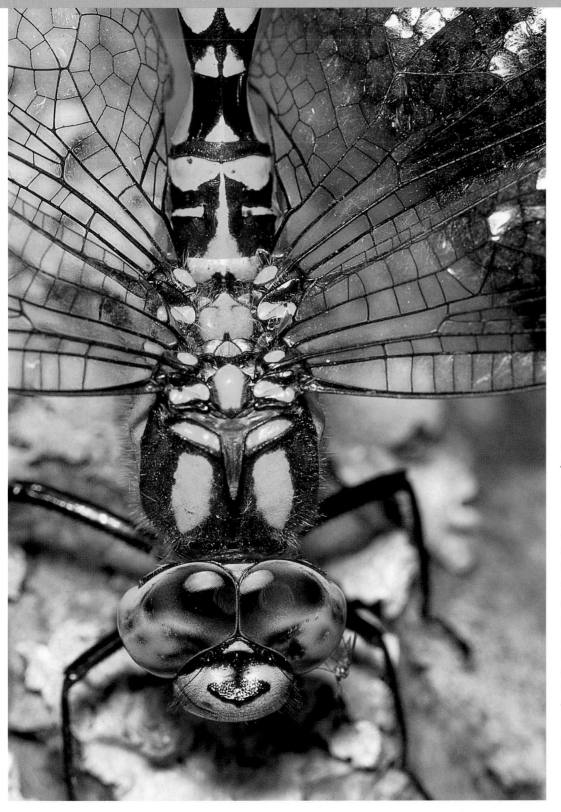

SOUTHERN HAWKER,
Aeshna cyanea. Sigma
70-300mm f/4-5.6 apo
macro. Fujichrome
Provia. **With a shy and
active dragonfly a
zoom lens is useful
because you can
change focus as you
slowly move closer,
getting whatever
pictures you can. Late
in the day when this
dragonfly was basking
in the sun I could even
fit the supplementary
lens and get a close-up
shot.**

two-element design computed to match the optical configuration of the lens and does not incur the problem of light loss which accompanies extra extension (see page 36).

Supplementary lenses can, of course, be used with zoom lenses to extend their close-focusing capabilities (see page 32) and the results are at least as good if not better than an in-built 'macro'

facility. Extension tubes can be used with zoom lenses – I regularly use a single tube with a 70-210mm f/2.8 AF zoom, and get excellent results.

A tripod or monopod is essential with these longer lenses and some have a mounting ring fixed to the lens. If not, Cullman make a universal fitting or specialist engineers can come to the rescue with custom-made adaptors.

MANY macro lenses with autofocus allow you to get down to life-size: higher magnifications require more specialised equipment, but you may find that adapting or coupling lenses already in your possession will allow you to achieve results of high quality. Stability and portability are practical considerations when investing in equipment for close-up photography in the field.

Supplementary Lenses

A supplementary lens can be bought for about the same price as a filter and these lenses offer a useful introduction to close-up photography. The simplest have a single glass element – a 'positive meniscus' lens – which is fatter at its centre than the edges, like spectacle lenses used to compensate for long sight or in reading glasses.

Supplementary lenses screw into the front filter thread of the taking lens to produce a lens combination of shorter focal length. This enables you to focus closer although the lens will no longer focus on distant objects. Supplementary lenses are convenient and easy to use:

• They can be slipped into a pocket for carrying.
• They leave the maximum aperture of the main lens they are used with unchanged.
• All automatic functions of the camera, such as exposure, metering and autofocus, are preserved.
• There is a greater working distance between the subject and the front of the lens than with an extended lens at the same magnification.

In contrast, only the most expensive extension tubes allow you to retain full camera control and the image brightness decreases because the lens is moved away from the film plane in use.

There can be disadvantages: my first excursions into close-up work were made using a cheap supplementary lens and the results looked as if they had been taken through the bottom of a milk bottle. As a rule, any piece of glass placed in front of a well-designed lens will produce some image degradation. Things changed dramatically when I learned never to open the aperture of the main lens wider than f/8. With smaller apertures, light rays closer to the axis of the lens are used to produce the image and the result, as with teleconverters (see page 42) is a reduction in spherical aberration which produces a much sharper image.

ACHROMATS

Two-element supplementary lenses – achromatic doublets (see page 23) – which have their surfaces coated like those of prime lenses, are much more expensive (three or four times the price of simple supplementary lens elements) but the end results are in a different league and, as a result, many serious photographers use them.

Some top lens makers use supplementary lenses as a way of getting higher magnification. In these cases the supplementary is computed to match the prime lens. Examples are the close-up attachment for the Olympus 80mm f/4 macro 1:1 bellows lens (which allows it to provide a reproduction ratio of 2:1), the Nikon medical micro lens and

above

MALE SILK MOTH ANTENNAE. Sigma 70-300mm f/4-5.6 apo macro at f/16 with supplementary lens to give 1:1 magnification. Single SB25 flash. Fujichrome Velvia. **A supplementary lens turns a high-quality zoom into an excellent general purpose objective. The supplementary lens is computed to form a part of the optical system.**

SUPPLEMENTARY LENS.
Convenient and easy to use, supplementary lenses are small and easily portable, and leave the maximum aperture of the main lens unchanged.

the Zeiss Tessovar. Sigma began supplying a two-element achromat with their first 70-210 mm 'apo' zoom design in preference to any other method for getting higher magnification. This practice is continued with the latest 70-300mm zooms which are supplied with a supplementary lens to allow a genuine 1:1 magnification.

Nikon makes several achromats (designated 3T, 4T, 5T and 6T) in two different powers (1.5 diopter and 2.9 diopter) for two thread sizes (52mm and 62mm). Stepping rings allow you to use them with other filter sizes. They are designed to work best with both prime lenses and high-quality zooms (of any make with a suitable front filter thread) of between 80mm and 200mm focal length. Few supplementaries are made with diameters to cope with large lenses.

HOW THEY WORK

Supplementary lenses change the focal length of any lens with which they are used. Whatever the focal length of the main lens the supplementary makes the infinity focus change to the same distance (roughly 1 ÷ power in diopters, e.g. a 2D lens gives a 0.5m focus).

The lens's own focus mechanism will allow slight further adjustment but, in general, the longer the focal length of the prime lens the greater the effect on the magnification: the usual supplementary lenses hardly change the focal length of shorter focal length lenses.

REVERSED LENSES AS SUPPLEMENTARIES

Reversed lenses (see page 40) are, in effect, high-quality, highly corrected supplementary lenses which open up tremendous possibilities for field-work without huge expense when they are stacked with lenses of 100-200mm focal length.

PRAYING MANTIS,
Mantis religiosa. Sigma 70-300mm f/4-5.6 AF apo macro f/16 with supplementary lens to give 1:1 magnification. Natural light with SB25 flash as fill in. Fujichrome Velvia. **With a supplementary lens all automatic functions of the camera, such as exposure, metering and autofocus, are preserved. There is also a greater working distance between the subject and the front of the lens than with an extended lens at the same magnification.**

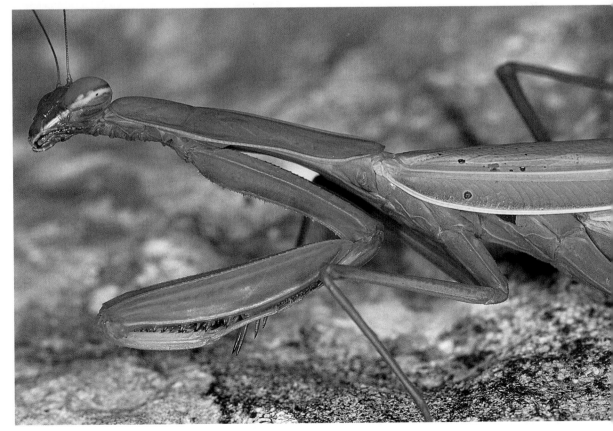

Stacked Lenses

Adaptors are readily available which screw into the filter thread of a lens and couple it in reverse on to the filter thread of another lens. This is known as 'stacking'. The lens of longer focal length is fixed to the camera while the front lens becomes a high-quality, highly corrected supplementary lens.

This technique works very well with a prime lens of between 100mm and 200mm focal length fixed to the camera with a lens of anything from 50mm to 24mm coupled to it. Experiment is essential because some combinations cause 'vignetting' – darkening at the edges of the viewing screen and on film – usually where a wide-angle lens is used as the supplementary. The lens corrections are optimised for close-up work when used in reverse and you can of course combine any two makes of lenses without having to obtain special adaptors for the purpose.

A 200mm f/4 or 135mm f/3.5 medium telephoto works very well with a 50mm f/1.8 lens. There is no need to use larger aperture lenses, which will mean an increased possibility of flare at the front surface, and of vignetting. The closer the filter thread sizes of prime lens and 'supplementary', the better.

In practical terms, magnification obtained by stacking allows a much better working distance than with 50mm or 100mm macro lenses on tubes. This is important not only in order not to scare shy subjects but also to allow light to fall on them from your flashgun (see page 70).

The magnification of the combination is found by dividing the focal length of the prime lens by that of the lens reversed on to its front. For example, my 200mm f/4 lens with a 50mm f/1.8 gives a magnification of $200 \div 50 = 4 \times$, which is pretty good for revealing scales on a butterfly's wings.

In use, the prime lens is set at around f/16 which serves two purposes: first you need every bit of depth of field you can get; second, this ensures that the image is formed from rays which come through the centre of the reversed lens, where even the cheapest ones are well corrected. (The reversed lens is set at its widest aperture and does not affect the taking aperture.)

As long as you have the coupling rings you can experiment with all the lenses you have, zooms included. In theory, a 200mm prime lens with a 24mm wide-angle reversed on to it would give nearly × 8 magnification, but vignetting would be severe. In cases like this a short extension tube between the camera and the lens can be used to enlarge the image circle and fill the frame, removing the dark edges.

When higher magnification is needed in the field, stacking lenses is an excellent way to achieve it. A set of enlarger lenses of different focal lengths provides a convenient set of 'dedicated lenses'. Used in reverse the image circle will always cover 35mm and the lens corrections will be optimised.

The maximum magnification I would contemplate in the field using stacked lenses is × 4, and then only very occasionally. I have tried zooms as stacked lenses, both as the prime lens and the 'supplementary': I have yet to find a combination which works well enough.

below

LARGE WHITE BUTTERFLY EGGS. Nikon 200mm f/4 coupled with 50mm f/1.8, single Nikon SB23 flash, × 4 magnification. Fujichrome Velvia. **For occasional work at higher magnifications, a 'stacked lens' provides an excellent way of getting sharp results without special purpose macro lens heads. Even garden 'pests' can prove to be an interesting subject as they hatch from their sculpted eggs.**

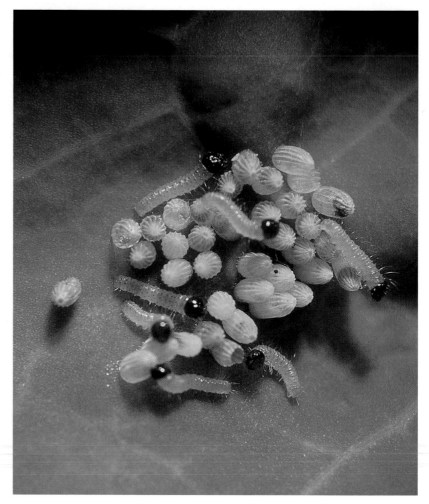

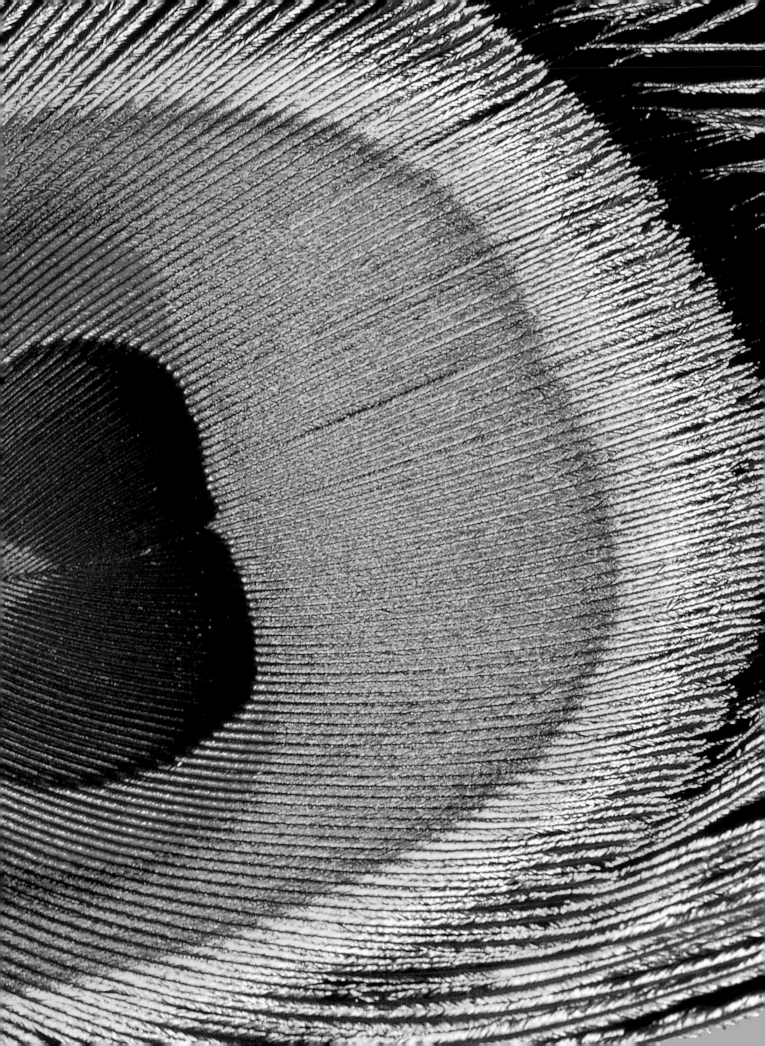

4

SUCCESSFUL photography depends on the correct exposure of film. Light intensity is usually measured using an exposure meter and then converted through a scale to a set of possible combinations of shutter speed and aperture suitable for a film of given speed. Modern exposure meters have a sensitivity and accuracy early photographers could only have dreamed of, yet a high proportion of pictures still come back from the processing lab showing poor exposure. If you understand exactly what an exposure meter measures you can get a much higher rate of success – especially with 'difficult' subjects.

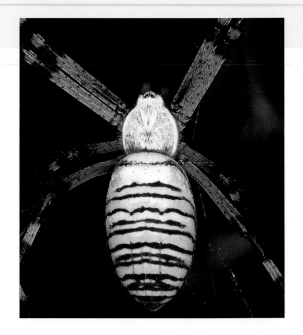

Exposure Meters

Exposure meters fall into two broad categories: hand-held and integral. Hand-held meters, as the name suggests, are used separately from the camera and can be used in the camera position to measure light reflected from the subject (reflected light metering) or in the subject position (incident light metering). Many professionals work only with hand-held meters and prefer the incident mode since it measures the light actually falling on a subject and is not fooled by subject reflectivity. Spot meters are the best of the reflected light meters because they measure a narrow cone of light. The more sophisticated meters can also register flash exposures or a mixture of flash and daylight.

Integral light meters are built into the camera body and measure reflected light. Most camera meters now work through the lens (TTL) and are directly coupled to the shutter speed and lens aperture. Modern camera meters usually offer a range of metering patterns:

• **Average metering** assesses an overall exposure for the scene.

• **Centre-weighted metering** concentrates the response towards the centre of the field.

• **Spot metering** responds to a small central area of the viewfinder. Olympus introduced a variation

of this which permitted several spot readings to be made and then averaged by the camera.

• **Multi-zone metering** splits the viewfinder into a number of zones (an example is Nikon's matrix-metering). To get a value for the exposure, the camera's meter cells compare the relative brightness of the segments in the pattern with a range of patterns held in memory. The more segments, the greater the possibilities: the most recent meters (such as the Colour Matrix system in Nikon's F5 camera) assess colour reflectivity as well.

For a wide range of subjects these built-in meters work perfectly and ensure a high proportion of correct exposures. They can fall down where scenes have a wide range of contrasts, or include either highly reflective or unusually dark subjects. This is where the photographer needs to have the confidence to take control.

WHAT THE METER DOES

An exposure meter is calibrated to give correct exposures with so-called 'mid tones'. An 18% reflectance grey card is an example; red roses and green grass are others. But confront the meter with a bright yellow flower, for example, and it will try to expose this as grey. The result will be a very

above
ORB-WEB SPIDER,
Argiope Bruennichi.
Nikon 60mm f/2.8 AF macro at f/6. Fujichrome Velvia. **Built-in meters work perfectly for a wide range of subjects but they can be confused by scenes showing strong contrasts, or which include either highly reflective or unusually dark subjects. You will need to take control in such cases.**

dark, dull yellow on film. Again, in a scene containing bright areas and dark shadows, if you expose for the bright areas the shadows will be too dark to retain detail; expose for detail in the shadows and the highlights will be burned out.

COPING WITH EXTREMES

The biggest problems for any meter are whites – the plumage of a swan, white flowers or snow – and blacks, such as a black labrador. There are several ways to deal with tricky situations which will fool the meter:

• **Meter from a grey card.** This depends on holding a grey card so that it is illuminated in the same way as the subject – in restricted areas or with sensitive subjects this might be impossible, but you could meter from the card and then swing the camera back on to the subject.

• **Run tests with tricky subjects.** With subjects which reflect a lot of light (white flowers, yellow flowers) you will need to over-expose to counteract the meter's tendency to register them as grey tones. The best way is to use the camera's exposure compensation dial which allows you to change exposure in 1/3 stops (remembering to return it to normal after use). Choose a metering mode in which the subject dominates and the meter is not trying to consider the background – use spot metering if you have it.

In practice I find yellow flowers need +2/3 to +1 stop over-exposure, white flowers need +1 to +11/3 stops to retain detail (which means being exposed as a very light grey rather than pure white on film). For dark butterflies or spider bodies I close down by −2/3 to −1 stop. And, just to make sure, I bracket exposures.

• **Control tone.** To do this your camera needs to have an exposure meter with a manual mode which allows you to vary exposure in 1/3 stops. You can meter any tone you like and then decide how bright or dark you want it to appear.

• **Bracket exposures.** Take a range of exposures from under- to over-exposure. For example, take five shots at −1, −1/2, meter reading, +1/2 and +1 stop by varying the aperture (or make 1/3 stop changes using the exposure correction dial). Some cameras permit this automatically.

TONE CONTROL

stops - close down by:

+21/2 *featureless*
+2 *extremely dark*
+11/2 *very dark*
+1 *dark*
+1/2 *slightly darkened*
 mid tone - meter
−1/2 *slightly lightened*
−1 *light*
−11/2 *very light*
−2 *extremely light*
−21/2 *featureless*

stops - open up by:

By taking a meter reading of any colour and then opening up or closing down the aperture (or using the compensation dial) you can control how that tone will appear. For example, metering a red object gives a 'medium' red: close down 1 stop to get dark red, or open up 1 stop to get light red. The grey scale shows how white would appear if metered directly: opening up by 11/2 stops gives very light grey which will retain detail; increasing exposure by 21/2 stops gives burned out, featureless white.

WILD ORCHIDS, *Orchis italica***, in Cyprus.**
Nikon 28mm f/2.8 at f/16. Fujichrome Provia.
If you take the time to appreciate exactly what an exposure meter measures, you will dramatically improve your success rate. Here the clouds were moving quickly across the sky and exposure fluctuated rapidly.

Lighting Quality

The overhead midday sun produces harsh shadows which are hard to ignore on film. Using a reflector to throw light into the shadows can help matters a great deal.

DIFFUSE LIGHT

For a lot of daylight close-up photography the best quality of light occurs on slightly hazy days where the light cloud cover acts as a giant 'umbrella'. For still-life work with natural subjects I far prefer this lighting to anything obtainable with tungsten, and frequently move the 'studio' to a patio table or into a conservatory. Surprisingly, although light levels might be low, flower colours can still appear vibrant on dull, even rainy, days – especially with Fujichrome Velvia film. The air is often still and working with a tripod can give excellent, sharp results.

BACK-LIGHTING

Few exposure meters can cope with scenes where you are shooting straight into the light unless there is a 'spot' mode. The background dominates and the foreground is grossly under-exposed. This is not a problem if you deliberately want to create silhouettes: against a setting sun, for example, you have to make sure the sky appears bright by over-riding the meter. If you want detail in the foreground, you will have to expose for the subject: here it pays to move in on the subject with a 'tight' composition to exclude as much of the washed-out background as possible. You can have the best of both worlds by exposing for the background and then using fill-in flash to raise the light levels in the foreground (see page 78).

BLACK-VEINED WHITE, *Aporia crategi.* Nikon 105mm f/2.8 AF macro with +1 stop under-exposure. Kodachrome 64. **White subjects are often a problem for exposure meters – you need to over-expose to counteract the meter's tendency towards 'grey' and yet the white must be reproduced as very light grey not pure white to retain detail.**

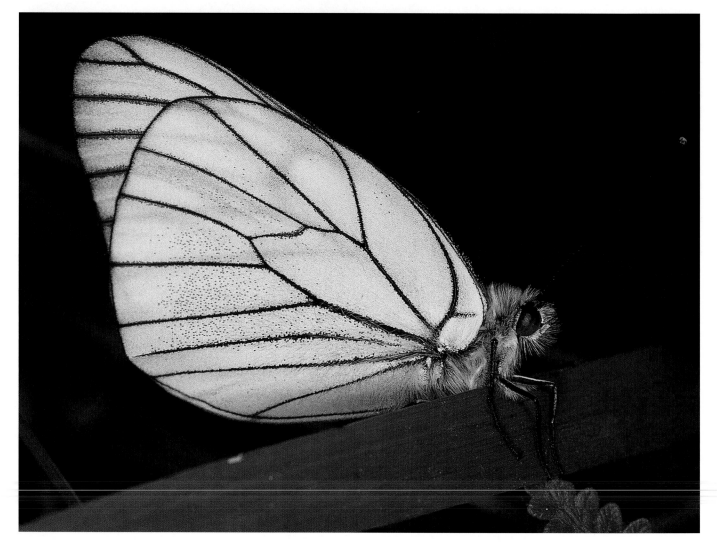

region of the spectrum. Films are designed to give what the manufacturers feel people prefer – true colours might seem dull and insipid, whereas people want their holiday memories invoked by punchy, saturated pictures.

ADDITIVE AND SUBTRACTIVE COLOURS

The colour image on a television set is made up of tiny dots of red, green and blue; other shades are created by adding together varying amounts of these three primary colours (together the three make white). This is the additive principle. The colour illustrations in this book are also made up from coloured dots – this time the 'complementary' colours magenta, yellow and cyan, plus black. Colour reversal films also rely on magenta, yellow and cyan dyes which work by 'subtracting' from the white light used to view them. A magenta dye allows red and blue through, yellow transmits red and green, and cyan transmits blue and green. Where these dyes overlap they transmit light of the common colour, for example, magenta and yellow both allow red through while blue and green are absorbed.

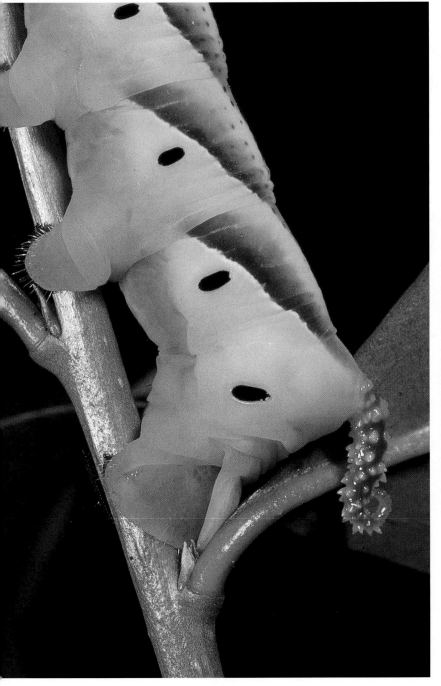

DEATH'S HEAD HAWK-MOTH LARVA, *Acherontia atropos.* Nikon 105mm f/2.8 AF macro with SB21B macroflash. **Two photographers can look at similar pictures on the different films they used for the same subject and swear they each got it right. Here Kodachrome 64** *left* **and Fujichrome Velvia** *above* **have been used to photograph the same caterpillar but render the yellow quite differently.**

Film Sensitivity

The light sensitivity of a film is expressed as its ISO (International Organization for Standardization) rating, which has superseded both the ASA rating (American Standards Association, numerically the same as ISO) and the German DIN (Deutsche Industrie-Norm) number: you still see ISO and DIN numbers together on a film carton: for example, ISO 50/18° and ISO 100/21°.

Doubling the ISO number doubles the shutter speed you can use at a particular aperture, so ISO 100 is twice as 'fast' as ISO 50. If the correct exposure with the ISO 100 film is f/8 at $1/250$ sec, for ISO 50 it will be f/8 at $1/125$ sec *or* f/5.6 at $1/250$ sec. A doubling of shutter speed or ISO number is equivalent to a 1 stop aperture change. Increasing the DIN rating by one represents a $1/3$ stop increase in speed.

Because fine-detail rendition is all-important, the most useful films for close-up work have ISO values between 25 and 100.

CORRECT EXPOSURE

A colour film is designed so that it is 'correctly exposed' when a certain amount of light falls on it. If you collect up those bits of paper which come in a film box and look at the pictograms for sun, light cloud and so on you will notice that all films give their correct exposure in bright sunlight, north or south of the equator, for an aperture of f/16 when the shutter speed is set as near as possible to the same numerical value as the film speed. For example, ISO 125 film at $1/125$ sec and ISO 50 film at $1/50$ sec. (ISO 64 at $1/50$ sec and ISO 100 at $1/125$ sec are very close to correct.) Kodak dubbed this their 'sunny f/16 rule' and it works extremely well (see page 56).

EASTERN LARKSPUR, Turkey, in late evening light. Nikon 24mm f/2.8 AF at f/16, 2 sec exposure. Fujichrome Velvia. **When colour films are used at low light levels, the colour balance may shift because the three colour layers react in different ways to very slow speeds, and exposure will need to be increased more than the camera's meter suggests.**

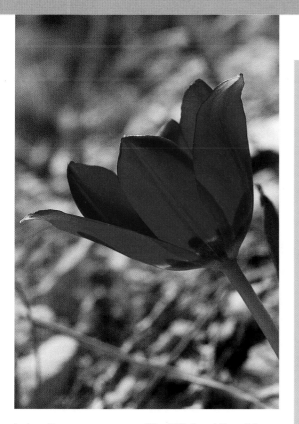

below **Coastal flowers, West Wales.** Nikon 24mm f/2.8 at f/16. Fujichrome Velvia. **Colours are given a 'cooler' feel on an overcast day – this can be corrected with a warm-up filter (81A, 81B or 81C according the degree of warmth you wish to impart to the scene).**

Light source	Colour temp (K)	Conversion filter for daylight-balanced film	Exposure increase
Clear blue sky	10,000 – 15,000	orange 85B	$2/3$
Open shade in summer sun	7,500	warm-up 81B or 81C	$1/3$
Overcast sky	6,000 – 8,000	warm-up 81C	$1/3$
Sunlight noon overhead	6,500	warm-up 81C	$1/3$
Average noon daylight (4 hours after sunrise to 4 hours before sunset)	5,500	none	
Electronic flash	5,500	none	
Early morning or late afternoon	4,000	blue 82C	$2/3$
1 hour before sunset	3,500	blue 80C	1
Tungsten photopearl	3,400	blue 80B	$1 2/3$
Quartz bulbs	3,200 – 3,400	blue 80A	2
Tungsten photoflood	3,200	blue 80A	2
Household lamp 100W	2,900	blue 80A + 82C	$2 2/3$

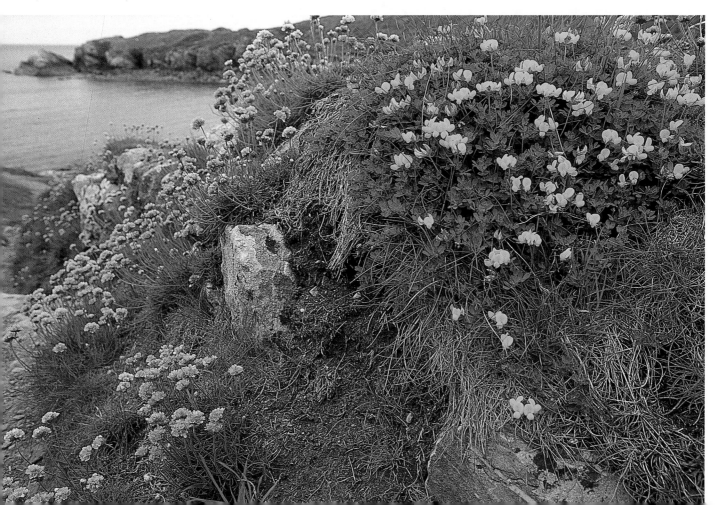

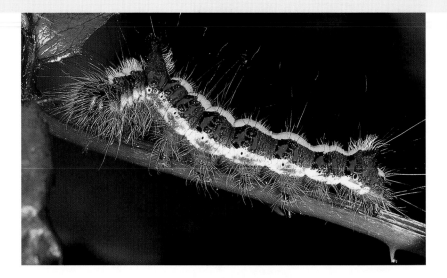

IN CLOSE-UP photography the perennial problem is the need to stop down a lens to provide depth of field. This forces the use of a relatively slow shutter speed and the slightest movement of subject or camera will adversely affect the sharpness of the result.

Using Flash Systems

Some photographers have a distinct aversion to using flash for natural history work, citing its unnatural look, unacceptable shadows and dark backgrounds as the evidence against it. These criticisms can be dispelled by careful choice of flash position and by making sure the background is close enough to a subject to be illuminated by the flash. Again, the mixing of flash and artificial light is possible if you choose a fine-grain film of speed around ISO 100. This is sensitive enough to respond to ambient light when the lens is stopped down to small apertures during flash exposure and some colour is shown in the background.

In the bright sunshine of a Mediterranean spring, basking subjects can be caught in close-up using natural light because the light intensity permits exposures on slower films – f/16 at speeds of 1/60-1/125 sec with ISO 100 film, for example. But, when the light is not favourable, or the subject too active, even the smallest of flashguns used near to the subject will provide enough light to give perfect exposure at life-size magnification using an aperture of f/16 or less. And the exposure takes place within an action-stopping 1/1000 sec or less, the time the flash pulse lasts.

Many cameras now boast through the lens (TTL) exposure systems which can control flash output, but excellent results can be obtained with older or less sophisticated cameras using the smallest and cheapest of manual flashguns.

SMALL FLASH UNITS

This is one of those cases where size does not matter for, from the subject's position, a small flashgun at close-quarters becomes a wall of light – a 'broad' source like a large flash with an umbrella or sunlight diffused by white, hazy cloud. Light sources such as these behave as an array of many small sources, which softens shadows.

Successful use of a small manual gun demands a bit of experimentation. When the correct position is found the method will give consistent results for most subjects and you will need to make adjustments only for highly reflective or dark subjects. A dozen or so test exposures will save much future wastage of film.

With a TTL flash system you can, in theory, use any flashgun close-up because the control system modifies the output power. Some trials might be necessary, however, because some systems tend to over-expose when they are used at close quarters. Although the control chip responds in a few billionths of a second the flash is not terminated quickly enough.

above

CATERPILLAR OF THE GREY DAGGER MOTH, *Acronicta psi.* Nikon 105mm, f/2.8 AF macro lens at f22 (x 1 magnification on film) with twin SB23 flashguns. Fujichrome Provia. **Flash is the ideal light source to reveal fine details, allowing exposures at small apertures with good depth of field and bright, saturated colours. The fast time eliminates blur due to subject or camera movement.**

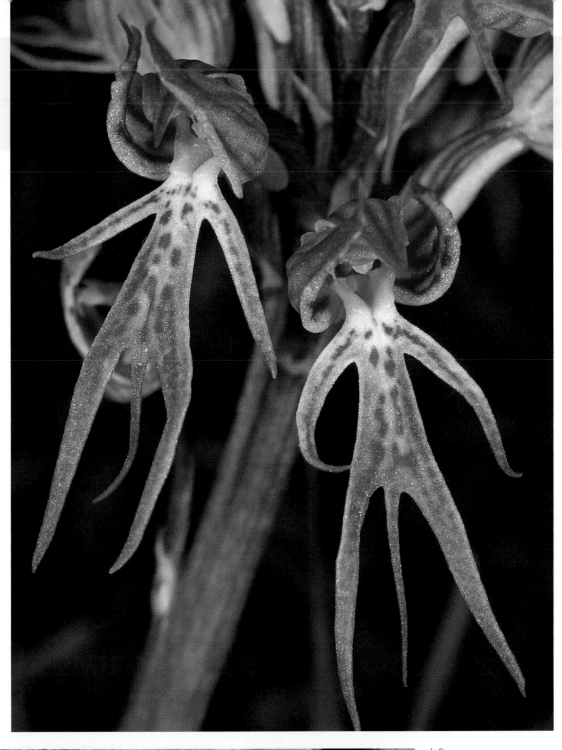

FLOWERS OF THE NAKED MAN ORCHID, *Orchis italica.* Nikon 60mm macro lens with single SB23 flash (x 0.75 magnification on film) Fujichrome Velvia. **A single flash acting as a broad light source creates enough shadowing to accentuate detail without the unnatural hard shadows often characteristic of badly used flash lighting.**

left

CENTIPEDE. Nikon 105mm f/2.8 AF macro at f/16. Fujichrome Provia. **A single SB25 flashgun was held above the subject and used with its diffuser in place because of a light drizzle which made the animal more reflective than usual.**

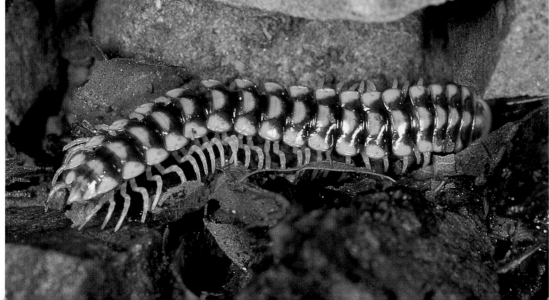

Positioning the Flash

To test a flash system, choose a subject with a good range of neutral tones – greens, reds, greys – and use a film of ISO 50-100 (faster films will over-expose). Make a set of exposures at f/8, f/11, f/16 and f/22 – perhaps at the end of a film used for something else. This is the guide for the next step. If the pictures are all too bright, repeat the test but move the flash further from the subject: if they are too dark move the flash closer to the subject. By trial and error, find the flash position for the best exposure at f/16 with the flash above the subject making an angle of 30-45° (as in the diagram).

When you use a higher magnification and move in closer, keep the flash above the same point on the lens. Although the lens is moving away from the film and reducing the light reaching it, the flash is moving closer to the subject and compensates for this loss since both processes obey the inverse square law (more or less).

Transparency film is much better for this test because machine-made prints are corrected automatically and your 'mistakes' – the very things you want to examine – disappear. Have the transparencies returned in strips or even as an uncut roll to make comparisons easier.

Your tests might show that at around half life-size (1:2) you can get away with one aperture but then need a different one at 1:1. To achieve correct exposure with white or other highly reflective surfaces the lens must be closed down a stop or so,

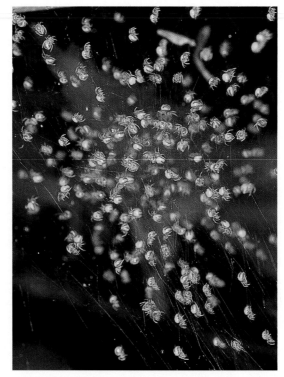

and opened up by 1/2-1 stop for dark subjects. All cameras vary so tests are essential.

When a flash is held above the lens in this position, light from the flash hits the subject surface at an acute angle and allows any slight unevenness to cause a tiny shadow – this is the 'relief' which accentuates detail dramatically and is a factor which contributes greatly to the impression of sharpness in close-up photography.

WOLF SPIDERLINGS, *Pisaura mirabilis.* Nikon 105mm f/2.8 AF macro at f/16. Fujichrome Velvia. **A Nikon SB21B macroflash was used to illuminate the spiderlings with both flash tubes as they scattered over their web: there was no way that all of them could be kept in focus, so several successive shots were taken of the changing pattern.**

facing page
ORANGE-TIP BUTTERFLY, *Anthocaris cardamines,* **feeding.** Nikon 105mm f/2.8 AF macro with single SB23 flashgun. Fujichrome Velvia. **The flashgun was near enough to both subject and background to ensure that both could be illuminated. The whites of the subject needed special attention: the TTL meter was set to 'spot' and a compensation of +2/3 stop applied to lighten tones and yet retain detail.**

POSITIONING THE FLASH

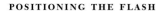

Hold the small flash over the same recognisable point X on the lens each time. This can be done by hand – less cumbersome than it looks – or by using a flash bracket. Commercial units to hold the flashgun can be purchased from several manufacturers including Stroboframe and Novoflex. Alternatively, couple together bits and pieces from the accessories rack in your local photo store with aluminium rod or bar where needed.

The angle made between the flash and the subject should be between 30°-45°.

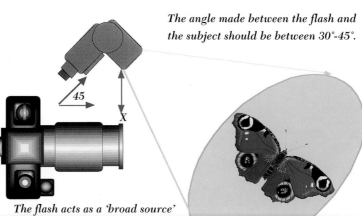

45

X

The flash acts as a 'broad source' of light at such close distances and thus does not create hard shadows.

below

OLEANDER HAWK-MOTH, *Daphnis nerii*. Nikon 105mm f/2.8 AF macro at f/16. Fujichrome Velvia. **Macroflash units work wonderfully well with a wide range of subjects. With 90-105mm macros their power means apertures smaller than f/8 could be unusable if you are too far away from the subject: they work best from 1:2 to 1:1 and beyond when there is enough light to use f/16 for good depth of field.**

TWIN-FLASH UNIT BASED ON SB23 FLASH UNITS. A pair of flashguns on a bracket offers more versatility than most other outfits, can cost less and still be portable: I use a pair of Nikon's small SB23 flash units which provide far greater output than any commercially available macroflash. The same could be done with equivalent units for any other camera system.

NIKON SB21B MACROFLASH UNIT. I have found the Nikon flash unit extremely useful and reliable – although it looks a bit like a ring flash it certainly produces a much better quality of lighting with good relief. The Nikon TTL flash system which controls it is the best I have used.

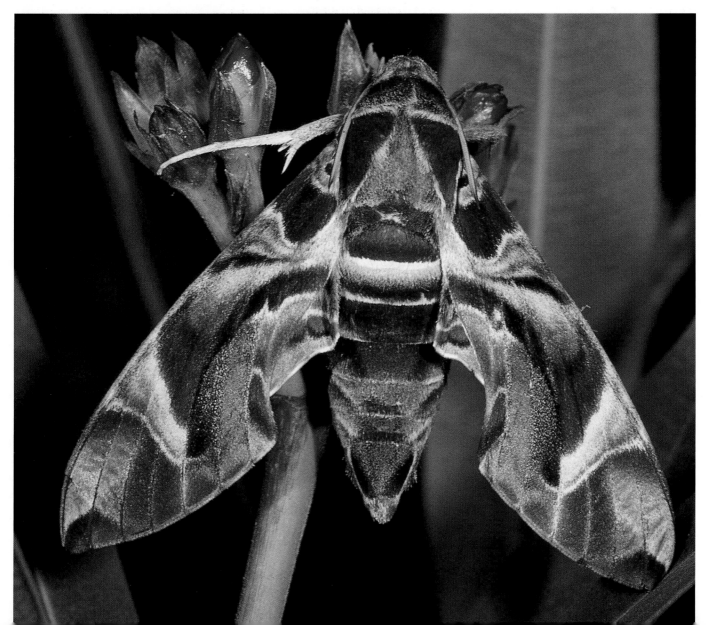

Building a Macroflash Set-up

In view of the costs and performance limits of commercial macroflash set-ups it is worth building your own – maximum versatility can be achieved with a twin-flash set-up. Mine is a cannibalised version of the defunct Kennet macroflash, using a pair of 'pre-owned' Nikon guns. The most expensive items were the connecting cables – you cannot make your own since plugs are, unfortunately, not available to the general public. In the USA the Saunders Corporation produce the very robust Stroboframe units (imported by Newpro UK Ltd). In all these set-ups the guns are held well off the lens axis and the relief provides beautiful results with one flash acting as the main light and another for 'fill-in'. A third could be added for background but stretches the bounds of imagination as far as portability goes.

In comparison with a Nikon (or similar) macroflash, or even a single small flash, these units are cumbersome. Flashguns held on arms seem almost to attract bushes which wrap themselves around the flash leads and pull off the guns. For the same reason I have never been happy with flash brackets fitted directly to lenses – if these are pulled off the damage to the camera face plate will be very expensive and, with the advent of autofocus, I suspect that the loading then imposed on the lens motors would not be conducive to a long, trouble-free life.

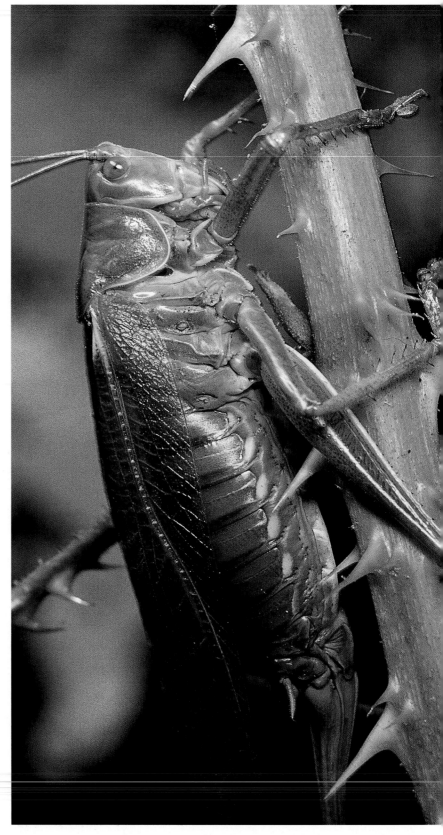

GREAT GREEN BUSH CRICKET, *Tetragonia viridissima*. Nikon 105mm f/2.8 plus SB21B macroflash. Kodachrome 64. **The sky was metered first and the camera set to manual which allowed me to adjust the synch speed to make sure the background was slightly under-exposed – the TTL exposure took care of the cricket in the foreground.**

Fill-in Flash

A subtle mix of flash and daylight can create natural-looking results. Portrait photographers often use fill-in flash outdoors to lighten facial shadows and lower the range of contrasts a film has to handle – this involves using daylight as the main light source. You can decide on the lighting ratio you want by taking the exposure from the background and then setting the flash manually.

Lighting ratio	1:2	1:3	1:4	1:6	1:8
Stops by which flash output reduced	1	$1^1/_2$	2	$2^1/_2$	3

The technique works very well for flower or animal portraits, adding 'bite' to the colours of the subject yet retaining a natural look. If your camera has matrix metering and a matched flashgun, fill-flash is available at the flick of a switch or two.

Occasionally, I like to mix flash and daylight so that the background is under-exposed by about 1 stop compared with the subject. The background is metered first and the aperture set in manual mode to under-expose by 1 stop. TTL flash is used as the main light for the subject. On dull days or in woodland habitats, shutter speeds have to fall to $1/_8$ sec or longer to get natural light in the background, making subject movement likely: choose your moment of exposure carefully or your pictures will have a sharp image with ghosts. When photographing subjects with TTL flash and a blue sky as background, closing down a whole stop below the camera meter's reading can produce an unnaturally dark sky. The easy way out is to rely on the camera's matrix metering if you have it, or just to close down a fraction of a stop below the meter's reading so that the flash will be triggered.

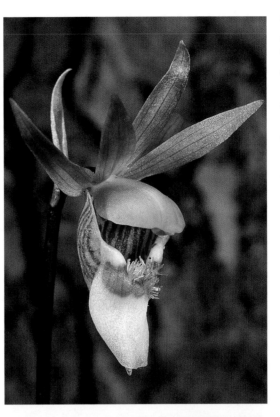

Calypso, *Calypso bulbosa.* Nikon 105mm f/2.8 macro at f/16 with single SB25 flash. Kodachrome 64. **An exposure for natural light was first taken with the camera in manual mode. Using a synch speed of $1/_4$ sec allowed deliberate slight under-exposure of the background with natural light. The camera's TTL meter set on 'spot' controlled the flash out put mixing natural and artificial light.**

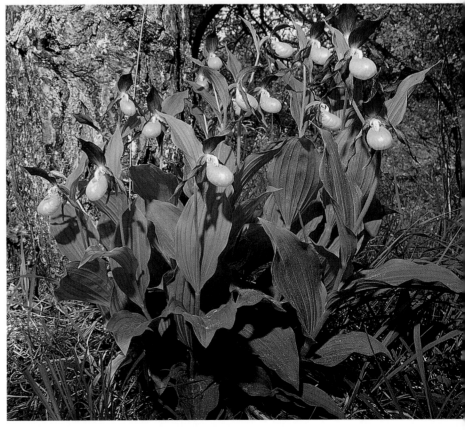

Lady's slipper, *Cypripedium calceolus.* Nikon 24mm f/2.8 plus SB25. Fujichrome Velvia. **I often use fill-flash with plants growing in woodland shade, setting the Nikon SB25 flash to give about 1 stop less than the ambient light level. This lifts the shadows and at the same time seems to give some 'bite' to otherwise muted tones.**

No Problems – Only Challenges …

The judicious use of flash can solve some of the perennial problems of close-up photography, but there are some pitfalls to be avoided.

BLACK BACKGROUNDS

When used with living subjects, black backgrounds are a source of contention: some people consider them dramatic while others deplore the unnatural look. Fashions change and depending upon your point of view, black backgrounds are either a bonus or the inevitable curse of using small flashguns, resulting in the rapid fall-off of light into the background.

One answer is to break up the uniform blackness by having leaves, twigs or bark close enough to be illuminated – they produce a blur slightly darker than the foreground which is easy on the eye and which, if uniform, can accentuate the sharpness of the main subject. If your subject is an insect on a flower, try changing your stance so the flower head forms most of the background.

HIGHLIGHTS

Unless you happen to be a nature photographer on Superman's natal planet with its two suns, twin highlights such as those produced by macroflash units are not found naturally. Pictures of the eye of a death's head hawk-moth were in perfect focus, but when I noticed the twin highlights I was no longer happy with the shots. If you use twin-flash, beware of tell-tale twin reflections in water droplets on leaves or hanging on spider webs.

HIGHLY REFLECTIVE SURFACES

Shiny surfaces such as beetle wing-cases produce 'hot-spots' with flash. These can be prevented by using a white tissue or handkerchief over each flashgun as a diffuser, or employing a commercially

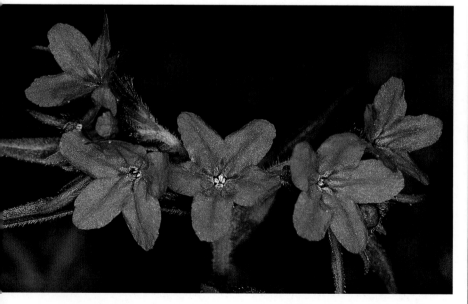

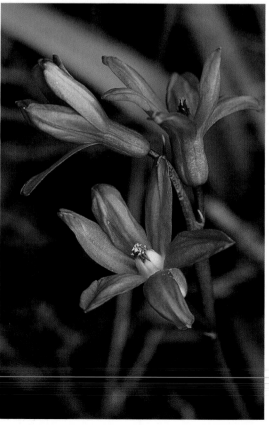

PURPLE GROMWELL, *Buglossoides purpureo-caeruleum above* **and LADY LOCK'S CHIONODOXA,** *Chionodoxa lochiae,* **in Cyprus** *right*. Nikon 105mm f/2.8 AF macro at f/16. Fujichrome Velvia. **A flash tube produces a surprising amount of infra-red; the best light source to use is 'cold' daylight – an overcast day. Lady Lock's chionodoxa was photographed with natural light in the shade, whereas the slightly reddish tinge to the purple gromwell results from flash.**

BUPRESTID BEETLE, *Chalcophora mariana*. Olympus OM2n with 80mm f/4 macro lens head and twin-flash set-up. Kodachrome 64. **Not all flash reflections have to be suppressed. In general, beetle wing-cases are highly reflective but here it was essential to preserve the reflection with its coppery sheen by using a twin-flash set-up with tissue over each gun.**

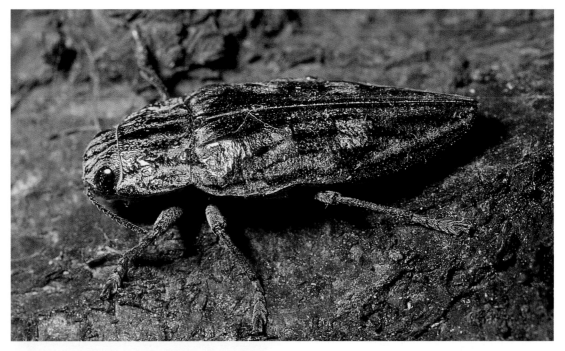

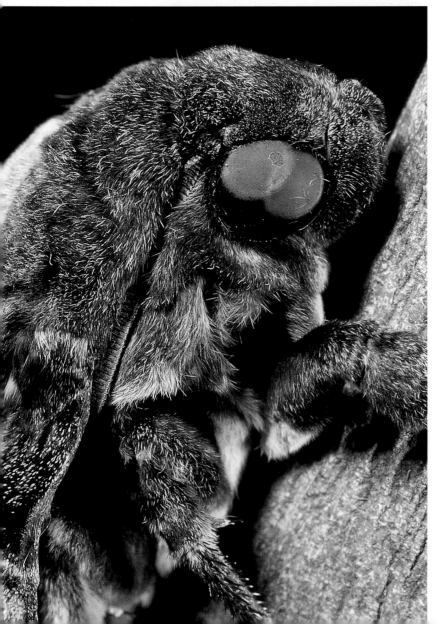

made 'softbox' such as the Lumiquest. Some photographers fix diffusers to both flashguns as a matter of course because they prefer the light quality obtained that way.

BLUES

The pigment in some blue flowers reflects infra-red rays which affect film, although it is invisible to our eyes because of the difference in response to light. Although the light discharged from a krypton gas-filled strobe tube is slightly bluer than daylight, the tube still produces infra-red and some blues come out badly. It is difficult to predict which blues will be affected – some gentians (but not all) can appear reddish on film. Morning glory, *Ipomoea*, is one of the worst. Natural light in diffused light or shade still works best – I often photograph blue flowers on rainy days. Kodachrome 25 gives the most realistic blues of all films, free of the reddish cast. Some people advocate the use of blue colour correction filters – but these can affect the colour balance of the whole picture and result in a very 'cold' feel to the greens of other vegetation. Kodak suggest a filter pack but the light loss is so great it is impracticable in the field.

EYE OF A DEATH'S HEAD HAWK-MOTH. Nikon 105mm f/2.8 macro AF with SB21B macroflash. Kodachrome 64. **Try to avoid using the two tubes of a macroflash unit with anything which will produce highlights because those two tiny spots will be a giveaway and spoil the picture for you.**

Tungsten Lighting

Apart from their visible light output, tungsten lamps produce a lot of heat which can be uncomfortable for living subjects, so I tend only to use them in the studio for still-life and copy work, or for focusing before using flash for the main exposure on an optical bench (see page 144).

Specialist film units which deal with macro cinematography often use focused tungsten or quartz-iodide lighting, but with heat filters to produce a 'cool' light which does not barbecue their small subjects. Alternative sources include fibre-optic lighting units which allow intense beams of light to be directed exactly where they are needed.

For copying work, tungsten lighting is convenient (see page 132). Commercial or home-made stands can be equipped with reflector lamps or with photoflood bulbs intended for studio lighting: these are filament lamps with a slightly higher colour temperature than tungsten lamps for household uses, to suit the colour balance of films designed to work with tungsten sources.

Working with small tungsten lamps in the home studio has the advantage that you can experiment and see directly the effects you get – so you can tell where you need to supply fill-in or reduce reflections. This is essential when working with glass, crystals of any sort and metallic jewellery (see page 130). Using polarisers to cut down reflection is a hit and miss business with flash and you often don't see the 'hot spots' until the film comes back from the processor.

In commercial studios using roll film and larger formats, extensive use is made of lighting heads which include a photoflood lamp for setting up the lighting exactly as required and a flash tube for the final exposure. Every set-up can be checked using a Polaroid film back – essential where you need to see the results immediately and expensive sheet film is to be used for the final exposure.

Living creatures such as fish in tanks can respond strongly to continuous lighting, either moving towards it or scuttling away to hide. Heating small fish tanks may have dire consequences for the occupants, whereas reptiles are often content to bask in the heat of reflector lamps.

When assessing exposure for a particular lighting set-up a grey card can be placed in the subject position and metered by the camera: alternatively, an incident light meter/flashmeter can be used to measure light intensity.

Small quartz iodide spots are useful in providing enough light for focusing at higher magnifications –

ORIENTAL CARVING made from a parasitic vine. Tamron 90mm f/2.8 SP AF macro at f/16. Fujichrome 64T. **A pair of desk lamps fitted with 100W reflector photofloods were used to depict a wooden carving against a backcloth of black velvet. The advantage over flash is that the lamps can be rearranged until you see the effect you like. Studio flash heads which incorporate a modelling lamp offer the best of both worlds – at a price.**

ORNAMENT. Tamron 90mm f/2.8 SP AF macro at f/16. Fujichrome 64T. **In 1898, my grandmother, then a 20-year-old lady's maid, bought this ornament on a visit to Paris. The surface carries a high glaze – it was photographed using a simple system: a pair of desk lamps with tracing paper diffusers against a curved sheet of coloured card.**

they are small enough to be fixed next to a flash head so that you get a pretty good idea of how your flash exposure will look. They are also useful if you decide to experiment with back-lighting in the studio or with dark-ground illumination (see page 136). The most versatile is the series of 12v 50w mini spot lighting heads, part of IFF's Macro 2000 rostrum bench. They can be used alone or with light pipes and filters, and are well ventilated.

Slide projectors are much neglected light sources, useful for lighting glass from the side or rear via a diffuser sheet. Coloured filters can be placed in the slide carrier.

COOL LIGHTS

Camera accessories manufacturers Kaiser and Novoflex (and many microscope manufacturers) supply 'cool' lamps which are essentially a quartz iodide lamp system – much like a slide projector – with heat filters to remove infra-red radiation. The light is conducted through two or more fibre-optic bundles in flexible tubes and can be directed on to a small subject. These lamps are an expensive investment unless you also do a lot of work with a stereo microscope – for which they are the ideal light source.

BUTTERFLY: Victorian hand-coloured illustration. Tamron 90mm f/2.8 SP AF macro at f/16. Fujichrome 64T. **Pictures from books, sections of maps, and stamps can all add interest to talks. A copy stand and a pair of desk lamps with reflector lamps arranged to give light at about 45° offers a reliable way of taking pictures – if the lamps are fixed the exposure is the same each time (with fine-tuning for very reflective or dark subjects).**

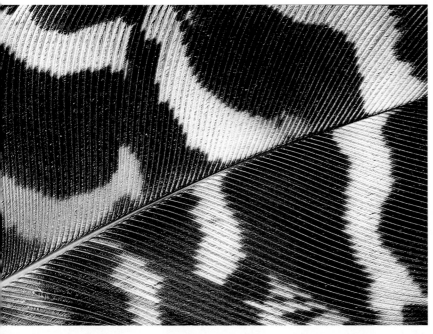

PEACOCK BREAST FEATHER. Tamron 90mm f/2.8 SP AF macro at f/22 with SB21B macroflash. Fujichrome Velvia. **The eyed feathers of a peacock usually get the photographer's attention. This breast feather was picked up in a park and arranged so that the vein lay diagonally across the frame and divided pattern areas.**

below

LICHEN GARDEN, west Cork. Mamiya 645 super with 45mm f/2.8 wide-angle. Fujichrome Provia. **My preferred time for photographing lichens is in late evening when the low light accentuates lichen patterns. But in west Cork on a rainy day the lichens on rocks almost seemed to glow and formed abstract 'gardens' set against a background of dark rocks.**

Action & Animal Behaviour

To create impact, still-life pictures have to rely entirely on a pleasing arrangement of objects and a subtle use of lighting, but in the natural world a sense of action can override any other element in a picture.

With moving images, the film-maker can build up the tension with a sequence of carefully edited shots leading to the main action; he can also show the aftermath. The still photographer has to use his or her knowledge and understanding of the subject to choose the moment which captures its essence. More often, the integral motor drive in the camera will be used to obtain a sequence from which individual frames can be selected.

CRESTED BASILISK LIZARD. Tamron 90mm SP f/2.8 AF macro at f/16 with Nikon SB25 flash. Fujichrome Velvia. **The way the subject is framed can introduce 'movement': for example, when it lies naturally along a diagonal this introduces a dynamic element to what is, in reality, a static composition.**

The photography of living subjects at close quarters takes a great deal of patience, especially when you want them to appear unaware of the camera and not to suffer any stress. By its nature this sort of photography is solitary – other people are a distraction. Successful photographers, whether taking stills or moving images, have to be totally dedicated to their art and spend many hours, often in cramped and uncomfortable conditions, just waiting for the perfect opportunity to photograph something which has not been seen before.

PSYCHOLOGY

Eyes are always important when photographing an animal. Your eyes, and those of anyone who sees your pictures, will be drawn to them as the first point of contact. If the eyes are even slightly out of focus the shot is useless, however sharp the rest of the picture. On the other hand, if you get the eyes in biting focus then other out-of-focus details will often be ignored – unless you feel the need to point them out. This is a very good way of making the best use of limited depth of field when you have to decide just what is going to be in and out of a narrow zone of sharp focus.

right **CRAB SPIDER in wait for Burnet moth on a toothed orchid.** Nikon 105mm f/2.8 AF macro at f/16 with SB21B macroflash. Fujichrome Velvia. **Taken as part of a sequence where an unsuspecting moth, feeding on nectar, approached doom in the shape of the crab spider. The picture showing 'anticipation' seemed more dramatic than later shots where the predator had taken its prey.**

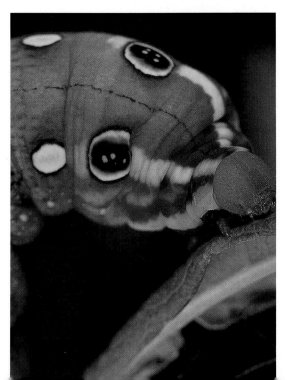

TREE FROG, *Hyla arborea left,* **and SILVER-STRIPED HAWKMOTH LARVA,** *Hyles celerio far left.* Nikon 105mm f/2.8 AF macro at f/16 with 25mm extension tube and Nikon SB21B macroflash. Fujichrome Velvia. **Eyes always become the centre of attention – in the frog they are sharp but not in the caterpillar so some of their impact is lost.**

Perspective & Viewpoint

BEE CAPTURED BY A CRAB SPIDER. Nikon 105mm f/2.8 AF macro at f/16 with SB21B macroflash. Fujichrome Velvia. **Dwarfed by its prey, the ambitious spider had been hiding in the orchid flower. Focus was controlled by moving the camera.**

Familiar objects can take on an entirely new look if you choose your viewpoint carefully. One challenge with natural history subjects is to make the 'common' as exciting as the rare. Experiment counts for a lot since you need to know how different effects can be produced with wide-angle, medium range and telephoto lenses and how standing in various positions will change your relationship with the elements of the picture: in other words, the perspective. Zoom lenses are a great aid to this part of the composition process, because you can change focal length with the twist of a wrist.

PERSPECTIVE

In school art lessons we all learned to draw boxes from sets of lines which converged at some point on the horizon, and how this can fool the eye into believing that something two-dimensional – a sheet of paper – has 'depth'. In close-up photography, distant elements are only important to the composition when wide-angle lenses are used to depict foreground subjects in the context of the landscape (see page 100).

For experiments with perspective, you can find a good viewpoint, then use different lenses (or a zoom) to see what effects you get. As the focal length increases the depth of field decreases because, in effect, you are increasing magnification. In short, a wide-angle lens sets something in its background, a telephoto begins to isolate it.

Alternatively, you can use lenses of different focal lengths while changing your position to keep the subject at exactly the same size in the viewfinder. Magnification thus stays the same, so depth of field remains constant, but with a telephoto lens you will have to stand much further away than with a wide-angle. As a result, the perspective changes because your distance from all the other objects in the frame has changed.

In close-up and macro photography the background is usually out of focus, but using a lens with a longer focal length will produce a slightly 'flatter' perspective of the subject at the same magnification. This results from the way parts of the object at slightly different distances from the lens tend to be 'compressed' together.

VIEWPOINT

The most important consideration in close-up work is where you place your camera to examine the subject. It is always worth taking time to look at the subject carefully and keep checking through the viewfinder as you change positions.

Several factors will influence the choice of camera position. The first should be impact but this might have to be moderated if the picture is for identification purposes. The second is to maximise depth of field to illustrate important details – which

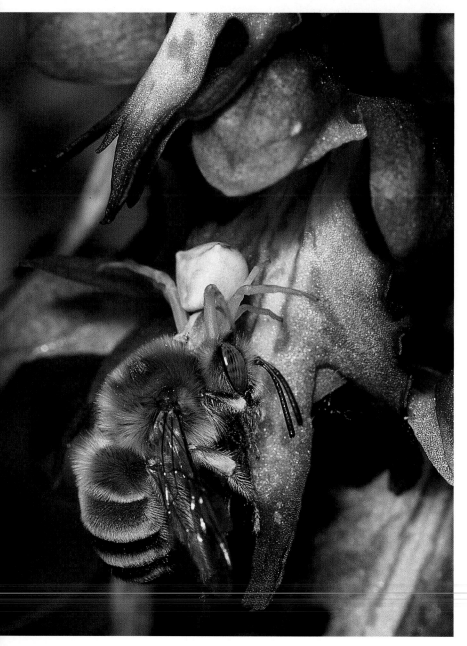

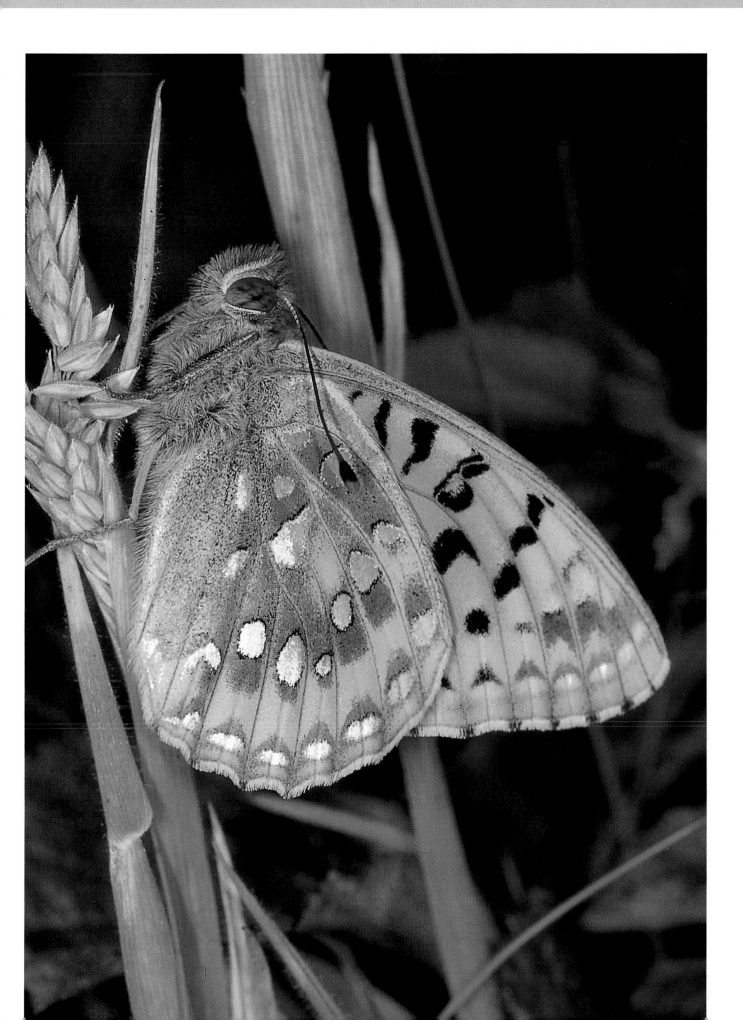

themselves. There is no accounting for taste, and some butterflies are attracted to the urine both for moisture and mineral content.

INSECT ACTIVITY

The time of day makes a great deal of difference to butterfly activity. Early on a summer's morning just after first light, some species will be found clinging to grass stems, covered with a sprinkling of dew. The sun's rays slowly warm them and they take to the wing – by midday many species are either active and will not settle, or are hidden away from the sun. I often go out in the early evening for a couple of hours before the sun sets, when many of the larger butterflies such as the swallowtails, fritillaries, painted ladies and red admirals seem content to bask and allow you to approach slowly and get close. At other times of day, many of these insects have a larger 'circle of fear' – to get a picture the photographer has to learn to stalk them (and be prepared for frustration even when using a long lens).

Whereas damselflies will flit around in the sun perching frequently, many dragonflies, their near relatives, appear to be more active. However, they will often return frequently to a well-placed twig or stem which permits them a view of their surroundings. The large, colourful hawkers often settle just out of reach: with their 360° vision they watch as you approach, you take aim and they flit off. Yet late in the day there is a short 'window of opportunity' when many hawkers will perch, basking in the warmth of the dying sun's rays before disappearing into the surrounding trees to roost.

above **BLACK GARDEN ANTS,** *Lasius niger.* Nikon 105mm f/2.8 AF macro at f/16 with single extension tube and Nikon SB21B macroflash. Fujichrome Velvia. **In high summer, you may see activity around cracks in paving stones as winged female ants crawl out for their nuptial flight. They climb up grass stems before taking off. A macro lens with extra extension or coupled lenses are needed.**

right **COCKCHAFER,** *Melolonthus melolonthus.* Nikon 105mm f/2.8 AF macro. Fujichrome Provia. **Most macro lenses in the 50-60mm focal length range have a deeply recessed front element which obviates the need for a lens hood. In use, this takes them very close to the subject – which is not ideal for shy subjects. A 90-105mm macro lens is better for general purpose work.**

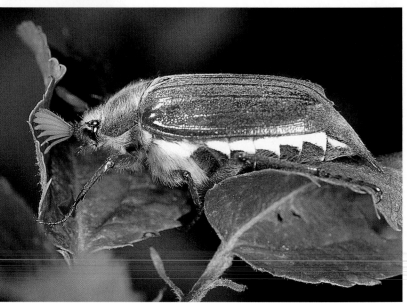

INSECT LIFE CYCLES

When making a study of an insect's life history I will often keep the various stages at home. I have done this with dragonfly nymphs in an aquarium and moth and butterfly caterpillars on their growing food plants, releasing the adults after emergence where I first found the larvae. In this way you can obtain sequence shots of the adult forms emerging and then photograph the perfect insect while it hangs from a twig waiting for its wings to fill out and dry. There is also time to photograph details of the insect, such as the head or the patterns of scales on the wings.

TECHNIQUES

For insect photography in natural light I now use Fujichrome Provia, with its combination of very fine grain and medium speed. In sunny conditions this permits exposures of 1/125 sec at f/11 or better – just enough to counter slight movement of subject or camera shake and retain depth of field. Some people use ISO 200 film and a faster shutter speed – I am not prepared to sacrifice the fine grain unless it is essential, and would rather use a mixture of flash and sunlight which I find works to my liking for many insect shots.

With a 105mm macro lens set at f/16 and 1:1 magnification there is an effective aperture of f/32: using Fujichrome Provia, a pair of flashguns and a synchronisation speed of 1/60 sec allows me to have flash as the main light source and yet retain background colour. On windier days you can use a higher flash synchronisation speed if your camera allows it but the background will be darker. With slower shutter speeds there is a risk of 'ghosting', where you get a sharp flash image with a fuzzy natural light image – this can be particularly noticeable at wing tips and along wing edges.

CTENIOPUS SULPHUREUS. Nikon 105mm f/2.8 AF macro at f/16 with Nikon SB21B macroflash. Fujichrome Provia. **Flower heads are a good hunting ground for many species of beetles and other insects in summer.**

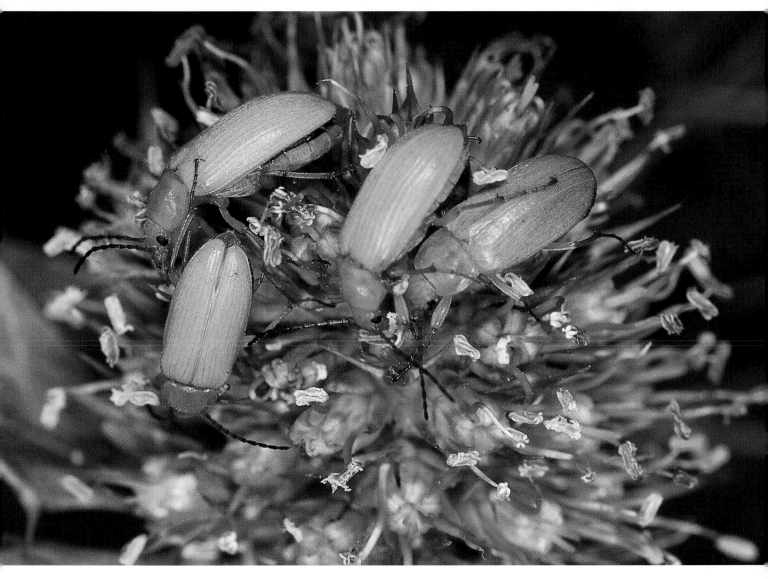

Macroflash in the Field

The question of a macroflash set-up has been considered already (see page 76) but some thought needs to be given to the type of set-up which will work for you in the field, as well as the way to use it to get the best results.

Some photographers take a purist attitude towards flash, citing its unnatural appearance because pictures of natural subjects with heavy shadows can look awful. But if you learn to control flash properly, you can use it to take pictures which are outstandingly sharp, have well-balanced lighting and do not feature black backgrounds unless you intend them to. I admit I like the 'bite' which flash imparts to both colour and sharpness when properly used with top-notch lenses and fine-grained films. With active insects and other small creatures, flash is a highly practical, action-freezing light source. A flower-filled meadow may contain hundreds of species of insects and you need to be able to work quickly and accurately and produce saleable pictures one after another. A good flash set-up permits this.

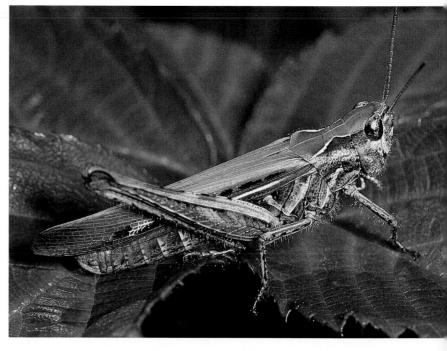

Ready-made devices such as Nikon's SB21B, the Yuzo macroflash and other similar systems supplied by major manufacturers are extremely useful. To some extent they all suffer from the fact that the flash tubes are set close to the lens axis, which reduces the modelling effect with longer lenses such as 105mm macros. And while they are excellent for magnifications from (0.5 to life-size and beyond, they are under-powered (apart from the Yuzo) when the lens is some distance from the subject and you are then restricted to a maximum aperture of f/8 or f/11.

You might find that a flash bracket – such as the now defunct Kennet macroflash, the Lepp made by Saunders, or something home-built – is a cheaper and more versatile option. For convenience, reliability and general portability I use a Nikon SB21B macroflash which, with a bit of fine-tuning, works extremely well. My first choice for insects is a pair of Nikon SB23 guns controlled by the camera's TTL system and mounted on a modified Kennet system. This permits better relief because the guns are further from the lens, enabling every wing scale to be picked out. One flash acts as the main gun and the other (often used with a neutral density filter) is the 'fill-in'. For shiny subjects I use tissue or tracing paper diffusers on each gun.

GRASSHOPPER. Nikon 105mm f/2.8 AF macro at f/16 with SB21B macroflash. Fujichrome Velvia. **It helps to have the background near to the subject when using flash so that it is illuminated together with the subject.**

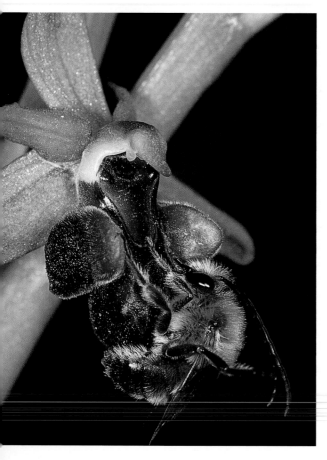

left
BEE POLLINATING ORCHID, *Ophrys mammosa*. Nikon 105mm f/2.8 AF macro at f/16 with SB21B macroflash. Fujichrome Velvia. **This male bee (*Andrena tuscosa*) is attempting to mate with the flower, attracted by a complex cocktail of scents which mimic the sexual attractant of the female bee.**

down the lens brings the background into recognisable focus and the perspective distortion makes it look 'real'.

PRODUCE

Good food photography of prepared dishes takes time, great skill and a certain degree of 'trade trickery'. It is more often than not a team effort involving photographer, technician and food economist because correct kitchen practice – particularly when food is for public consumption – adheres to strict rules and must be followed for the image to have credibility.

However, produce – particularly freshly caught fish, vegetables (whole or in cross-section), spices, grains, pulses and nuts – has great intrinsic beauty and can make intriguing still-life subjects, whether items are taken individually or in groups. If you are working outdoors, a garden table can be deployed as your studio and 'rough' props such as chopping boards, baskets and millstones can be used to effect.

Finger tapping bass technique. Tamron 90mm f/2.8 SP AF macro at f/16 with SB21B macroflash. Fujichrome Provia. **Close-up techniques can be used to illustrate techniques of all sorts from musicianship to crafts.**

and how close you want to go.

Although model locomotives in small scales are usually photographed indoors on a layout, larger models can be set in the foreground with real rather than model trees in the background. Lens choice is determined by how much of the model you wish to include (wide-angles for the whole model, medium telephotos for details). Stopping

Red cabbage. Mamiya 645 super with 80mm f/2.8 at f/16 Fujichrome 64T held in copy stand and subject lit with paired tungsten lamps at slightly different differences to create 'relief'. **Food, especially pulses, vegetables and fruit, can make fascinating close-up subjects. Here, while preparing borsch, I took a break and photographed the red cabbage in section while the hungry hordes had to wait.**

Dark Ground Illumination

Microscopists have long used the technique of dark ground illumination to produce dramatic photomicrographs of tiny organisms in pond or sea water. These subjects often show a high degree of transparency, and dark ground illumination helps pick out internal parts against a black background. Special purpose-built condenser systems are used at high magnifications but the principle can be exploited simply and effectively in the macro range by using a light box.

The subject to be photographed is raised above the light box on a sheet of glass – a microscope slide will do if the subject is small. A disc of black card or paper is placed on the light box surface immediately below the subject. This must be large enough to form a continuous background when examined through the viewfinder, but not so big that it prevents light spilling around the edges of the disc to illuminate the specimen.

Experiment is essential because the effect can change dramatically with the angle of the incident light. Raise and lower the glass plate to change the angle (about 45° is a good start) and observe the consequent lighting effects.

For the photographs reproduced here, the camera's own TTL exposure meter was employed and several bracketed exposures were made either side of the indicated value. The first set of pictures came back well exposed but, tellingly, revealed a flare spot in the centre of the frame which had not been visible in the viewfinder. This was eliminated with a small 'collar' of black paper which extended down to the subject to act as an extra lens hood. The guide exposures were used as a basis for experiment with dark ground illumination. The insects were trapped at slightly different levels in the amber, so getting both in sharp focus was almost impossible.

A light box makes it easy to explore the effects of dark ground illumination, and to get an idea of the possible results. This simple set-up works but a viable alternative is to use a pair of small flashguns instead of the light box. This permits faster shutter times and allows the camera's TTL flash metering to control exposure.

Anything with a degree of transparency can be lit in this way, from gemstones and minerals to thinly cut sections of vegetables such as tomatoes or peppers. Often, a mixture of dark field and incident light works best. Small pond creatures held in a Petri dish will have their details revealed by dark ground illumination, but you should use a 'cold' light box to avoid heating up the water in the dish and destroying the subjects.

When photographing larger subjects, support a sheet of glass above a board covered with black flock paper. (Some supposedly matt black paints are reflective enough to appear dark grey on film.) Lamps placed below the glass and to the side, well out of the field of view, provide the illumination. I tend to use tungsten lamps for focusing and flash for the final exposures.

MOSQUITOES IN AMBER. Canon 50mm f/3.5 macro used in reverse on bellows f/16. Fujichrome Velvia. **Raising or lowering the slide or changing the size of the disc subtly varies the back-lighting effect – experiment each time you use this set-up.**

a

a. The insects were photographed using a pair of flashguns (Nikon SB23) after first focusing with a pair of small tungsten lights in the same position as the flashguns. The camera's spot meter, with a compensation of + $^2/_3$ stop, controlled the exposure.

b. The upturned flash tubes of the Nikon SB21B macroflash were tried as a light source. Focusing was done using the light boxes as illumination. The exact effect was impossible to predict but in the event, with the same + $^2/_3$ exposure compensation, the experiment worked.

c. A simple silhouette resulted from placing the amber on the light box and using this as the light source.

DARK GROUND ILLUMINATION

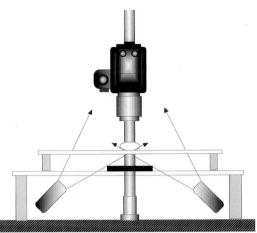

A microscope slide or a larger piece of picture glass suspended on wooden blocks of equal height supports the object above a light box (or sheet of glass). Illumination is provided by a pair of tungsten lamps or flash guns – the background is a disk of black card or felt.

c

b

Aquaria & Vivaria

LEOPARD GECKO, *Eublepharius macularius.* Tamron 90mm f/2.8 SP AF macro at f/16 with twin SB23 flashguns and large 'drainpipe' lens hood. Fujichrome Provia. **Captive subjects are often content to sit, basking like the small gecko in a vivarium with front removed. It is very important not to try and pass off pictures taken in captivity as being from the wild – however tempting it might be.**

facing page
LION FISH, *Pterois volitans.* Nikon 28-85mm f/3.5 - 4.5 AF zoom at f/16 with twin SB23 flashguns and large 'drainpipe' lens hood. Fujichrome Provia. **When photographing fish in large tanks it is difficult to drape sheets and cut reflections. Here, a water collector from a drainpipe top was painted matt black inside and out and used as a large lens hood; flashes on extension arms provided illumination. The zoom was essential for framing since many fish are curious and insist on coming to view the cumbersome, but effective assembly.**

An aquarium or vivarium sitting on a bench allows you a much greater degree of control than you can get when photographing wild subjects in their natural habitats. And the variety of potential subjects is unlimited because, in theory, you can photograph life forms from fresh water or the sea, and from locations as diverse as the tropics, the Amazon basin or the African lakes.

If you decide to photograph wild creatures from streams, ponds or rock pools, make sure you don't have far to travel so that they can be put back safely, quickly and unharmed. Animals taken from rock pools expire quickly as water is warmed and becomes de-oxygenated: they are best photographed *in situ* (some people take a small aquarium with them to the sea). The welfare of the subject must be paramount.

LIGHTING

Tanks can be lit in various ways – from the sides or from above – as the diagrams show. They can also be lit from the front as long as you take steps to kill any reflection of the camera (and photographer) in the front glass and position flashguns or lamps well to the side.

CONTROLLING REFLECTIONS

The potential problem with all aquarium and vivarium photography is reflection from the front glass surface: all those folk who happily shoot using compact cameras with integral flash in large public aquaria are doomed to disappointment when they get their results back.

One method often used to eliminate surface reflections is a black cloth, or a board covered with black flock paper, in which there is a hole through which the camera lens can protrude. A method I use – it may be inelegant but it works – involves a large 'lens hood' made from the kind of plastic collector fitted to the top of a drainpipe, which is sprayed inside and out with extra matt black paint. In use it is pressed against the aquarium glass while the camera and lens poke through the hole at the back. The camera is fitted with two small

flashguns mounted on a bracket so the size of the cowl must not be so large as to prevent light from the guns reaching the subject.

With a macro lens this approach is limiting, because at a fixed distance from the glass there is a restricted range of focus and fish are not likely to move where you want them to be in order to fit the picture you have in mind. A 28-80mm zoom has proved effective for framing but fish quickly become inquisitive, making front-end-on shots the only ones you get.

With a home aquarium the black cloth works best but when photographing (with permission) in either aquaria or vivaria where glass is involved I use my plastic 'hood'.

CUTTING OUT REFLECTIONS

A backcloth is placed behind the tank and the camera lens is poked through a hole in a black cloth or board just big enough to take it. This cuts out reflections from the front of the glass. Fish can move quickly in and out of focus and so it makes sense to restrict movement with another sheet of glass which will be invisible in the photograph. The tank can be lit in the normal way.

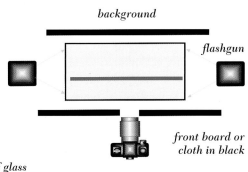

BACKGROUNDS

In a large aquarium, light fall-off from flash can mean that subjects will appear against a black background in your photographs. Using a more powerful flash with a diffuser can help here: I tend to use a Nikon SB25 or an old Metz 45CT1.

If you prefer a coloured background – maybe one painted in shades that suggest a weedy pond or a rock face -this can be mounted behind the tank. Illuminate it separately with a flash head, either connected to the main gun via a TTL cable or separately fired by a 'slave'. If the camera is not controlling the background flash then exposure tests are necessary.

THE VIEW

In text book illustrations, a full side view of a fish is preferred because this makes best use of depth of field and shows all the identification details you need. But endless pictures of fish filling the frame and all appearing to swim horizontally through the book can become tedious to look at. It is a good idea to try to photograph fish swimming at an angle to the viewfinder frame to give some idea of movement, or to show them in action such as feeding or turning. Even 'end-on' portraits can be very effective as long as the eyes are in sharp focus. As with any close-up work involving wild subjects, patience is needed together with an understanding of how the creatures behave. Many reef fish, for example, are more active at night – low lighting is available to simulate this and provide you with just enough light for focusing.

SETS

If you are trying to depict a fish in its surroundings, attention must be paid to the plants, rocks and substrate material used in the tank – model sunken galleons and plastic plants just do not look the part … There are excellent books available which describe setting up 'theme' tanks involving typical habitats and the creatures to be found there.

CHINESE WATER DRAGON ADULT. Tamron 90mm f/2.8 SP AF macro at f/16 with twin SB23 flashguns and large 'drainpipe' lens hood. Fujichrome Provia. **The lizard had positioned itself on a branch so that no amount of repositioning on my part could eliminate extraneous background. The only answer was to go for a 'head and shoulders' portrait.**

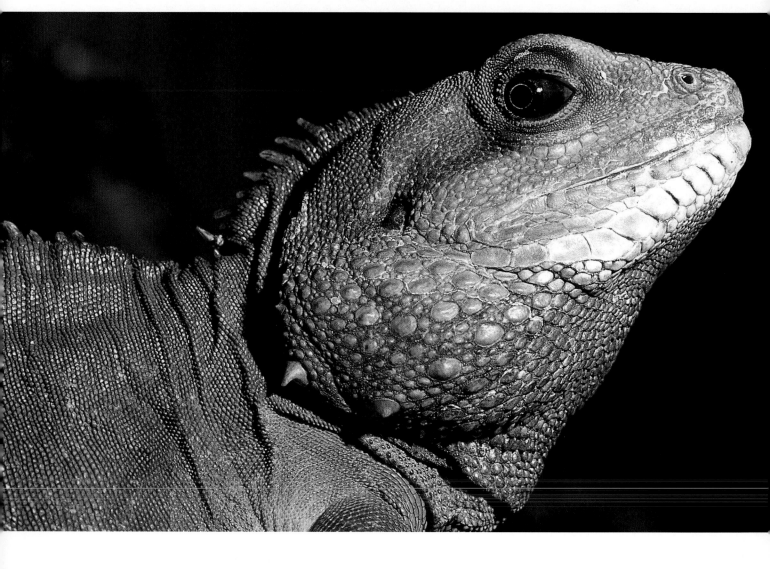

MICRO-AQUARIUM

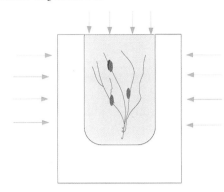

With smaller subjects, a piece of perspex cut in a U-shape can be put between the sheet of glass and the front of the aquarium, and the subject contained within the limbs of the 'U'. With front-lighting, ensure the flash makes an angle of more than 45° with the aquarium face to prevent reflections – changing flash positions creates side-lighting, top-lighting and back-lighting – even dark field illumination.

MICRO-AQUARIUM SET-UP

black background

Micro-aquaria can easily be made in any size from two pieces of clear glass (small borderless picture frames have ready-polished edges) separated by acrylic or perspex bonded with silicone cement. The camera can then be supported on a tripod and focus-slide for precise focusing.

GABON VIPER, *Vipera gabonica,* **FEEDING ON RAT.** Tamron 90mm SP f/2.8 AF macro at f/16 with Nikon SB25 flashgun. Fujichrome Velvia. **Various aspects of behaviour such as feeding, courtship and mating can contribute to a valuable scientific record, as well as making interesting compositions.**

Building the set takes time and requires an eye for detail, but the results are worth it. Visit the best public aquaria and see how they achieve a sense of realism.

It is best to avoid using photofloods or any other heat-producing light source which can disturb behaviour and also warm subjects uncomfortably in a small aquarium or vivarium. I prefer to use normal tank lighting for focusing and then expose with flash. The tank lighting is far too dim in comparison with the flash to unduly affect exposure or create a colour cast.

MICRO-AQUARIA

Smaller water creatures such as daphnia, blood-worms, mosquito larvae and backswimmers (water boatmen) would get lost in a normal aquarium. A suitable 'micro-aquarium' can be used with an optical bench or a camera fitted with bellows to photograph smaller creatures viewed from the side. Use waterproof silicone cement to fix a U-shaped piece of perspex or acrylic between two small pieces of glass – even two microscope slides if your subjects are very small. Alternatively, you can place them in a shallow Petri dish and view from above: I use a piece of perspex with a hole cut out to create a smaller 'pond' so that the creatures come back into view more often.

You can use any form of lighting you like – dark ground illumination can be particularly dramatic with some of the smaller creatures because they are translucent. You can use front-lighting as long as the flash makes an angle of more than 45° with the face of the tank, to prevent reflections hitting the camera lens.

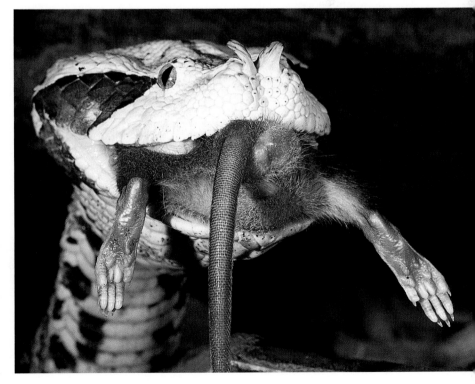

Building an Optical Bench

Most precision work in optics is done using some sort of optical bench. This is a support on which you can mount various components – in the case of macro photography, a camera and the subject you want to photograph – with some way of moving them precisely (and with freedom from vibration) to get sharp focus.

The problem of vibration is so serious that laboratory optical benches for lens testing are made from slabs of machined and polished granite – like enormous headstones for graves – which are mounted on cushioned anti-vibration mounts.

We can manage with something a lot less sophisticated if the intention is to work in the range from × 2-15 magnification on film. In the field, depth of field restrictions mean the slightest movement sends a subject out of focus – it is difficult enough to use × 2 magnification, and × 4 with stacked lenses is the sensible limit.

One way of countering vibration is to make sure that the camera and the subject you are photographing vibrate together. You can achieve this if the camera and the subject stage are mechanically coupled by fixing them to the same metal bar. Several camera manufacturers supply focusing 'stages' which can be fixed to a rod which slides between the focusing rails of their bellows attachments. Again, Olympus provides the best design with a rigid stand which turns their camera plus bellows into a small 'Photomacroscope'.

At low magnifications the dimensions of the support are not important but for high magnification cine work, for example, they are significant because they affect the natural tendency of the set-up to vibrate at a particular frequency (resonance). One important feature of any optical bench or stand is that you must be able to keep the subject at right angles to the lens axis and parallel to the film to avoid problems with the shallow depth of field.

The 'bench' I use I designed myself and is, in effect, Mark III. It is made from a cannibalised microscope stand; the first two were made from aluminium angle. I tend to start with an idea for a piece of equipment but no particular design – that is suggested by whatever I happen to be able to find in the large collection of bits and pieces I have saved over the years 'just in case'.

The stripped microscope stand is mounted horizontally (but can also be used vertically like a microscope). At one end the camera body is fixed to a bellows – a Nikon PB4. At the other the subject stage is an old focusing stage from a microscope which is smooth and precise in operation.

facing page

PURPLE HAIRSTREAK BUTTERFLY EGG, *Quercusia quercus*. Olympus 38mm f/3.5 bellows macro lens at f/11 with single SB23 flash. Fujichrome Velvia. **The Purple Hairstreak's egg is deposited near buds; when the larva hatches it burrows into the unopened bud. The tiny eggs were spotted on branches of a fallen tree – its 'sea-urchin' shape is revealed by x 10 magnification on film.**

left and facing page

MALE EMPEROR MOTH SHOWING EYE-SPOTS, *Saturnia pavonia*. Olympus 38mm f/3.5 bellows macro lens at f/11 with single SB23 flash. Fujichrome Velvia. **The prominent eye-spots reveal their structure at x 5 magnification on film as being constructed from scales. For subjects at this magnification a viewing screen with clear spot and cross hairs leads to the sharpest results. When there is no parallax between wing scale and cross hair – that is they do not separate when you move your head sideways – focus is exact.**

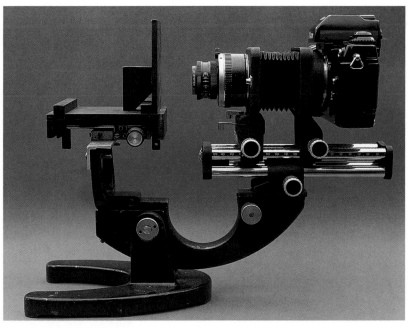

When loaded with a camera, the bellows that is the smoothest-focusing is the Novoflex. The focusing rail in most bellows is a fairly coarse rack and pin-ion which is surprisingly wobbly even at modest magnifications of a few times life-size. Better are the friction drives used in some enlarger stands or focusing stages for microscopes: screw drives, such as the Kaiser positioning device for cameras, are also better for precise focusing.

above **OPTICAL BENCH.** Mamiya 645 super with 80mm f/2.8 at f/11. Fujichrome Provia. **Although it might look complicated this home-built bench is assembled from a cannibalised microscope stand, Nikon bellows and an adjustable microscope focusing stage. It is rigid, yet provides a range of movements. Other people have used aluminium bar or even old lathe beds to get what they want. A single flash provides the best illumination.**

Using the Optical Bench

The bench is not always in use but can be put into action easily – inside or out – by rearranging cluttered surfaces in the studio-cum-study or pressing the patio table into use. I tend to get ideas for its use, 'play' for a few days and then, having got the results, get on with more conventional photography or writing.

In use the bellows is extended to give the magnification I want and then front and back panels plus focus slide are locked tight. Focusing is accomplished by moving the subject – a couple of home-made screw drives move the subject mount in the plane of focus to position it. Ample use is made of such 'high tech' material as scrap bits of 6mm (1/4in) medium density fibreboard and also plasticine, unrivalled for fixing bits of twig or stems.

After a great deal of experimentation the best light source I have found is a single small flashgun (Nikon SB23) generally with a diffuser controlled through the camera's TTL system. For each exposure the mirror in my Nikon F4 is locked up and I use the self-timer or a cable release so that my hands do not touch the camera. With the mirror locked up, the F4 can use a meter cell in its body which provides 'spot metering'. An assortment of lenses is used in stop-down mode and the meter gives consistent results for exposure with the usual

corrections of + 2/3 to + 1 stop over-exposure for light subjects and around – 2/3 stop under-exposure for dark subjects to counteract the meter's tendency to read everything as neutral tones.

Now that the test exposures have been made it gives a very high proportion of 'correct' exposures and those that are not correct are often 'interesting' rather than rejects.

The set-up can be used just as easily for transmitted light by placing the flash behind the object which is mounted over a hole in the stage. Black card masks the edges to prevent any light falling on the lens and causing stray reflections which might give rise to flare.

For best results I aim to work with subjects that are as flat as possible: this avoids problems with depth of field and the compromise that has to be made because of diffraction (see page 20).

The 'set' of macro lenses I depend on also illustrates what can be pressed into use. The special purpose lenses are three Olympus optics – the 80mm f/4, 38mm f/3.5 and 20mm f/2, purchased second-hand only when I felt sales justified it. A Canon 50mm f/3.5 macro used in reverse, an ancient 30mm f/2.8 Carl Zeiss Jena apochromatic lens (bought for a pittance), together with Bolex 25mm and 12.5mm cine lenses and various reversed Nikkor enlarger lenses, were and still are pressed into use when the occasion demands.

left

FEMALE HAZEL FLOWER.
Olympus 38mm f/3.5 bellows macro lens at f/11 with single SB23 flash. Fujichrome Velvia.
The familiar long yellow catkins or 'lambs' tails' are the male flowers of the hazel. The small female flowers which, when fertilised, will eventually form the nut are unobtrusive on the stems. A x 7 magnification on film reveals their structure.

facing page
STINGING NETTLE,
Urtica dioica. Olympus
38mm f/3.5 bellows
macro lens at f/11 with
single SB23 flash.
Fujichrome Velvia. **The**
hairs on a nettle are
revealed at x 7
magnification on film
as vicious hypodermic
needles ready to
discharge their
contents when
touched. On the optical
bench the camera is
fixed and the subject is
moved smoothly for
focusing. Aperture was
set at f/11 – any
smaller results in
image softening due to
diffraction.

DEATH'S HEAD
HAWKMOTH LARVA,
Acherontia atropos.
Olympus 80mm f/4
bellows macro lens at
f/22 with twin SB23
flashguns. Fujichrome
Velvia. **A set of macro**
lenses – spanning focal
lengths from 80mm or
so down to 12.5mm
gives an optical bench
great versatility,
enabling it to be used
from about x 0.25 – x
25 life-size. These can
be specialist optics or
a set of reversed
enlarger and cine
lenses.

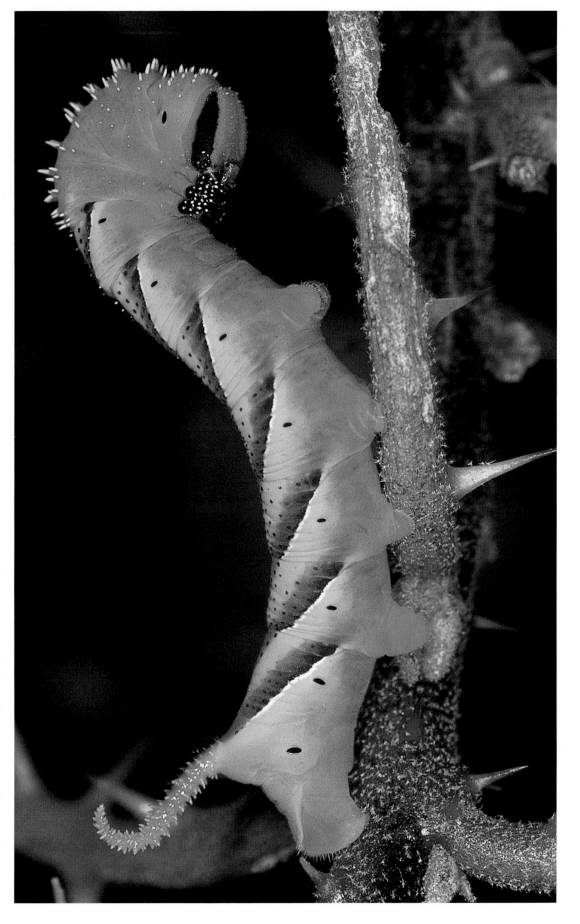

TAKING THE PICTURE is one side of photography – dealing with the photographs themselves, from storage through to use, is another. You will accumulate pictures at an alarming rate if photography becomes a passion. And if there is any commercial element involved, it is easy to get overwhelmed as pictures come back from the lab faster than you can file them. We all have to face the fact that folk who like being outdoors taking pictures would rather do that than sit at home captioning and filing the results.

Organising your Collection

I speak from painful experience when I say that you should catalogue your work sooner rather than later. Set up a computer database: any Mac or PC package will do (but make sure the data can be exported if you ever need to set up another database). Ask around, see what others use and choose something which will work for your particular needs – your catalogue should preferably be as simple as possible.

Over the years I have tried several filing systems. For a while my collection was divided into major categories – insects and their allies, other animals, birds, orchids, other flowering plants – to suit the material. I subdivided: within plants, for example, I began to file by botanical family, which suited the projects I was working on at the time, then alphabetically by genus within each family and by species within each genus. Problems arose when new pictures arrived and I had to rearrange things to preserve a sequence. And when I was away no one except me could use the system to answer calls from editors.

I now do a preliminary sort into the original categories – birds, animals, flowering plants, landscape – but within each category I file each picture almost as it comes, giving it a category number and identification number. The date, Latin name, locality (country, district, habitat type), 'behaviour' and a location using a filing sheet number are entered in the appropriate spaces in the computer 'card' for that slide on-screen using Claris Filemaker Pro's software. If I want to seek out all butterflies photographed in Cyprus on chalky soils I just tick the relevant categories and the computer does the search.

It was hell to set up and enter old data – I did this alongside new stuff to soften the blow but it was a very lengthy process. Now I accept the routine with new pictures.

CAPTIONING

A small laptop computer, or even an organiser, is worth considering if you are going to be spending time in hotel rooms. Any of the myriad ideas which come while I am out in the field can be recorded before they flee my mind and I can make a list of pictures taken – mainly Latin names, which are then sorted alphabetically. The list, written in Microsoft Word on a Mac, can then be merged with my database and also with Cradoc Caption

above

PICTURES ON A LIGHT BOX. Mamiya 645 with 80mm f/2.8 at f/11. Fujichrome Provia.
A light box is essential for convenient viewing and sorting of transparencies – many models are available commercially but any competent handyman can make one to fit the space they have available using daylight colour-balanced fluorescent tubes.